Endangered Edens

Exploring the Arctic National Wildlife Refuge, Costa Rica, the Everglades, and Puerto Rico

Marty Essen

ENCANTE
PRESS

Published by:

Encante Press, LLC
www.EncantePress.com
SAN: 850-4326

Printed in China through Four Colour Print Group, Louisville, Kentucky

All interior and cover photographs by Marty Essen, except where noted.
Interior layout and cover design by Tugboat Design

Publisher's Cataloging-in-Publication Data
(*Provided by Quality Books, Inc.*)

Essen, Marty.
Endangered Edens : exploring the Arctic National Wildlife Refuge, Costa Rica, the Everglades, and Puerto Rico / Marty Essen.
pages cm
LCCN 2015908259
ISBN 978-0-9778599-9-3

1. Endangered ecosystems. 2. Travel writing.
I. Title.

QH75.E787 2016 333.95'16
 QBI15-600119

10 9 8 7 6 5 4 3 2 1

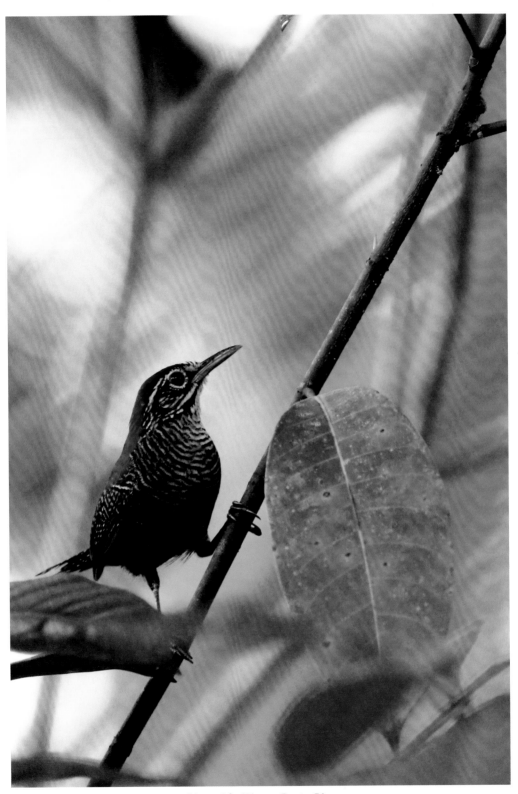

Riverside Wren, Costa Rica

Animals, Photos, and Thanks

Animals: I took liberties when determining the gender of some animals. If I knew their correct sex, I used it. If not, I took my best guess based on size, coloring, and behavior. Referring to animals I shared moments with as either "him" or "her" just seemed more appropriate than using a generic "it."

Photos: I adjusted most of the photos in this book for brightness and contrast. I also cropped some photos and digitally removed a few minor imperfections—such as raindrops on a lens. I did not, however, remove the spots on the Prudhoe Bay oil field photos, as they were caused by dirty bus windows. In general, I kept digital editing to a minimum. My philosophy, as a photographer, has always been that if a photo needs more than five minutes of digital editing, it's not good enough to use.

Thanks: As always, my first thanks goes to my wife, Deb. Not only is she my companion in travels and in life, but she is also my muse. Her suggestions and nudges (okay, *shoves*) were invaluable in creating this book.

Special thanks to Deborah Bradseth of Tugboat Design for her determination to make this book look great. Photo-intensive books like this one are challenging to lay out—especially when you're trying to create print and e-book versions that are equally appealing.

I also want to thank my beta readers for their proofing help, suggestions, and enthusiasm: Susan Bond, Barbara Cass, Lee Hall, Jacquie Helt, Tim Hill, Peggy Kohn, Patrice Loucks, Andrea Matson, Sue Rutford, Warren Spawn, and Linda Williams.

And finally, a big Thank You to Callie MaRae for lending her beautiful voice to my book trailer. I encourage readers to visit my website, check out the trailer, and share it with others. Also, keep an ear out for Callie's first nationally released album.

Contents

I dedicate this book to environmental heroes everywhere: you may not have holidays named in your honor, and strangers may not approach you in airports to thank you for your service, but the world is a better place because of your efforts.

Introduction

For a while, I thought I was going to be a one-book author. I put approximately twelve thousand hours into writing my first book, *Cool Creatures, Hot Planet: Exploring the Seven Continents*. After finishing that manuscript, I had difficulty rekindling the drive to write anything longer than a magazine article or a newspaper guest column.

Then, in December 2014, my wife, Deb, and I traveled to Costa Rica, where we had an amazing adventure. I came back from that trip rejuvenated and eager to write another book. Although I didn't return to the sixteen-hours-a-day, seven-days-a-week writing marathons of my first book, I did put in long hours each day, trying not to waste a moment while the words were flowing easily. As I kept saying to Deb, "I'm in the zone!"

Ultimately, I stayed "in the zone" for the entire time I was writing this book and even found myself smiling a lot during the writing process. Now that I've finished, I'm excited for you to read *Endangered Edens*. My hope is that you'll laugh and learn something while reading the stories, linger over the photos, and, perhaps once or twice, grit your teeth at the short-sightedness of people who see no value in protecting wild places.

This book contains four chapters, sequenced in the order the events occurred. Although I hope you'll read *Endangered Edens* from cover to cover, each chapter stands on its own. If you picked up this book because a particular chapter interested you, feel free to start with that chapter and return to the others afterward.

I chose to call this book *Endangered Edens*, because each chapter features

an adventure in a paradisiacal location that faces an uncertain future because of human activities. However, each of the four locations is at a different stage of endangerment:

Chapter 1: Puerto Rico Herpin' or: I Thought This Was a Girl Trip!

The island of Puerto Rico covers 3,515 square miles, and it has a population of roughly 3.6 million people. Add to that all of the tourists that visit each year, and one can easily understand why Puerto Rico is an *Endangered Eden*. Fortunately, most people congregate in the cities. As you'll see, when you read about Deb's and my adventure, we found some great natural places away from the human beehives.

Chapter 2: Arctic Eyewitness

Without a doubt, the Arctic National Wildlife Refuge's coastal plain is the most fought-over piece of land in the United States. The fight isn't between armed combatants; however, it's between the Democrats (and their environmentalist allies) and the Republicans (and their oil company allies). So far, conservation has prevailed over exploitation, but as long as we have a political system that allows corporations to buy influence, the Arctic coastal plain will always be at the mercy of the next election. As you'll see, when you read about Deb's and my adventure, the Arctic coastal plain is an *Endangered Eden* worth way more than anything an oil company or an oil company-controlled politician can ever give us.

Chapter 3: I Got Cottonmouth with Two Russians in the Everglades, but I Swear I Didn't Inhale.

The Everglades is an *Endangered Eden* in a lull between major endangerments. Not too long ago alligators, great egrets, and other iconic Everglades species were on the brink of extinction. Through conservation efforts, many of those species have made impressive comebacks. That's wonderful. However, many of those same species will become endangered again as climate change worsens and ocean levels rise—flooding their freshwater habitat with saltwater. As you'll see, when you read about my solo adventure, the Everglades is an Eden where people can find solitude and enjoy a wide variety of close-up bird and reptile encounters.

Chapter 4: Bat an Eyelash and Monkey Around in Costa Rica

Costa Rica is, by far, the least *Endangered Eden* in this book. The reason is because Costa Rica has one of the most environmentally enlightened governments in the world, and that government has worked to protect their country's future by setting aside roughly 25 percent of its land for conservation. Even so, Costa Rica will never be able to isolate itself from outside influences, such as climate change and the black market for animal products. As you'll see, when you read about Deb's and my adventure, Costa Rica may be as close to a paradise as you will find on our endangered planet.

Whether you picked up *Endangered Edens* online, at a local bookstore, or at a library, I thank you for doing so. I hope you will enjoy the stories and photos in this book as much as I enjoyed creating them for you. And if you do enjoy them, please do me the favor of posting a review on both Goodreads and your favorite bookstore's website. Your review could be a vital contributor to the success of this book and ultimately lead to the publication of a sequel featuring more *Endangered Edens*.

Okay, it's time to put on your virtual hiking boots. Let's head out on an adventure!

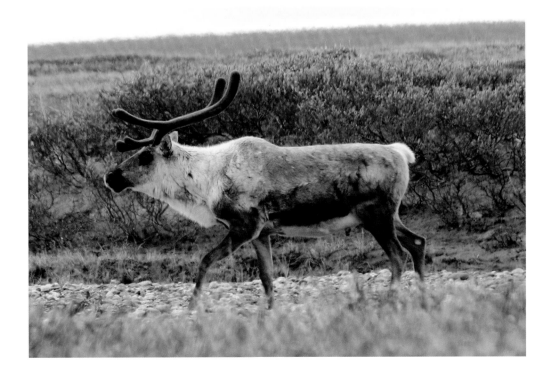

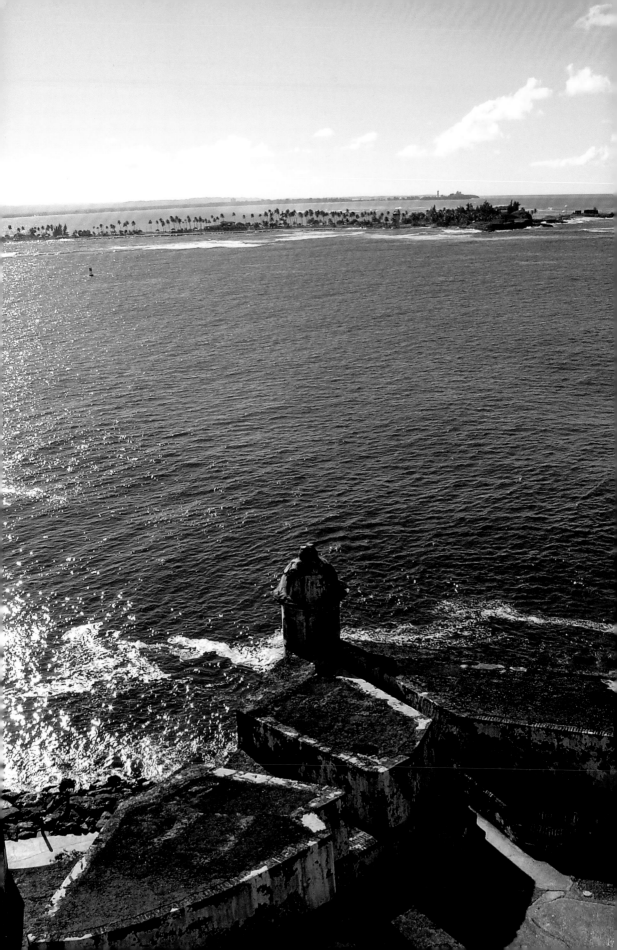

Puerto Rico Herpin' originally appeared in *Reptiles Magazine*. This chapter is a rewritten and expanded version of that article.

— 1 —

Puerto Rico Herpin' or:
I Thought This Was a Girl Trip!

When my wife, Deb, and I traveled for my first book, *Cool Creatures, Hot Planet: Exploring the Seven Continents*, we had some outstanding herping adventures in far-flung places. The only places we didn't see herps (herps is short for herpetofauna, an all-inclusive word for reptiles and amphibians) were in northern Canada and Antarctica. Rumors of my discovering two venomous snakes—a tundra taipan in the Yukon Territory, and an ice viper in Antarctica—have been greatly exaggerated!

Following our seven continents adventure, Deb ran for the Montana House of Representatives and the Montana Senate, I wrote my book, and we both ran small businesses. In all, we worked two years straight without taking anything more than a long weekend off. All that hard work made us eager to see something besides the forests and mountains surrounding our Montana home. Since our world travels had all been adventure-oriented and often involved physical challenges and primitive accommodations, my wife desired something more relaxing this time. You know—a girl trip, with indoor plumbing and time for tanning on the beach and shopping in the city.

When she suggested Puerto Rico, my initial interest was marginal at best. The island is overpopulated, overdeveloped, and the introduction of the mongoose has eradicated many of its herps. Nevertheless, I acquiesced to her wish.

My idea of an enjoyable trip is searching for wildlife—especially

herps—and photographing my finds. Knowing that Deb wouldn't mind if we spent a little time looking for animals, I did some pre-trip research and was pleased to learn that a variety of cool creatures still existed on the island. Of all the animals we could see, Puerto Rican boas excited me the most. Unfortunately, everything I read about the snakes said they were endangered and difficult to find.

To increase my chances of locating a Puerto Rican boa, I decided to seek local help. My inquiries led me to Dr. Armando Rodriguez of Inter American University. He was in the midst of a bat study and could take us to a cave where in fifteen years of visits he had seen Puerto Rican boas every time except once.

"Guaranteed snakes!" I exclaimed. This was something I had never experienced before in my travels. Even in areas where snakes were common, finding them had always been difficult. They just might be the world's best hiders. Suddenly, I couldn't wait to visit Puerto Rico.

Through one of our credit cards, Deb and I received certificates for three free nights at a Ritz-Carlton hotel. Luxury hotels aren't our style, but for free we could make an exception. We would spend our first two nights at the Ritz-Carlton in San Juan. After that, we would head to the island's quieter southern side for three nights at a funky little place called Mary Lee's by the Sea. Then, for our final night, we would return to the Ritz-Carlton.

The Ritz-Carlton is a massive, elegant hotel on eight acres of gated beachfront property. After Deb and I checked in, we enjoyed a candlelit dinner and headed for the beach. The sun had already set, so we had the beach to ourselves and were able to enjoy a long, romantic stroll under the stars.

Eventually, we decided to move the evening to our room. With my key card, I opened the gate at the edge of the beach, and we started across the hotel's pool and courtyard area.

Ko-Kee! Ko-Kee! Ko-Kee! Though neither of us had heard the sound before, we both knew instantly what it was.

"Coquí frogs!" exclaimed Deb.

All thoughts of romance went on hold. We were in herp mode!

When our initial search of the tropical gardens and manicured bushes in the courtyard didn't produce any frogs, I decided we needed more than just the hotel's subdued lighting. I ran up to our room, grabbed my camera and two flashlights, and returned to the courtyard.

As we intensified our search, the song "Puttin' on the Ritz" played in my head—with the lyrics altered to "Herpin' at the Ritz," of course. I don't know which I enjoyed more: being back in herp mode after a two-year hiatus or knowing that several fashionably dressed guests were surreptitiously watching our "odd" behavior.

Even with flashlights, the coquí frogs were difficult to find. We could hear them calling all around us, but they would stop whenever we came close.

We were crouched at the edge of a sidewalk, shining our flashlights into a clump of ferns, when a trendy-looking young woman approached us. "Did you lose something?" she asked.

"No," I replied. "There are coquí frogs in the garden, and we're trying to find them."

"There are animals in there?"

"Yes. Frogs."

"*Ewwww!*" She grabbed her male companion's arm and hurried into the hotel.

Finding the first frog took the longest, because we weren't sure whether to look on the ground or on the plants. Once we realized that the frogs were most often on the topside of leaves obscured by other leaves, we started having more luck.

The frogs were common coquís—a light brown species, not quite as big as my thumb. Puerto Rico has sixteen species of coquí frogs, but only two make the distinctive *ko-kee* call. One thing all coquís have in common is that their young bypass the tadpole stage and develop directly from eggs.

Other than coquí frogs, our night of herpin' at the Ritz also produced a marine toad (the world's largest species of toad, with some weighing more than three pounds) and several anole lizards. Not bad for a hotel courtyard in a city of 395,326 people!

Coquí Frog

We spent the next day shopping and sightseeing in the Old San Juan Historic District. For part of the day, we just walked around and soaked up the atmosphere. The district dates back to 1509, as a Spanish settlement. We also had lunch at a restaurant that looked like a dive but served great sandwiches. Old San Juan, with its

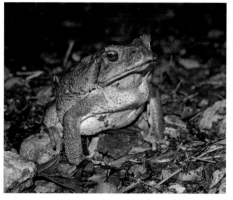

Marine Toad

cobblestone streets and colorful buildings, was quite wonderful. Later we explored Castillo San Felipe del Morro, a sixteenth century fort, with massive outer walls and tall *garitas* (wall-mounted turrets). As for shopping, the Puerto Rican rum we bought here was much better than any Puerto Rican rum we ever bought at home. As one bartender told us, "We don't export the good stuff."

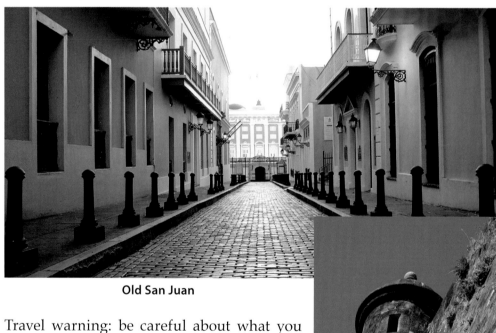

Old San Juan

Travel warning: be careful about what you bring home from Puerto Rico. At the end of our trip, we bought two bottles of our favorite Puerto Rican rum at the duty-free shop in the Luis Muñoz Marín International Airport. Unfortunately, when we changed airplanes at Newark Liberty International Airport, security officials confiscated our bottles. Considering that Puerto Rico is a U.S.

Castillo San Felipe del Morro

territory, and the duty-free shop had sealed our package, taking away our rum was just mean. And you know they didn't just throw those bottles in the trash. I hope the conspiring TSA agents all got terrible hangovers.

San Juan

After another night at the Ritz-Carlton, we headed southwest to Mary Lee's by the Sea, near the town of Guánica. Because our visit took place the week before Thanksgiving, we hit a rare lull in Mary Lee's schedule and were the only guests.

Bright tropical colors and eclectic knickknacks decorated our one-of-a-kind self-contained apartment, and a thin line of mangroves buffered us from the ocean. From this base, we would go exploring, hiking, and sea kayaking. And, if we wanted to stay close and just enjoy the sights, sounds, and smells of the ocean, we

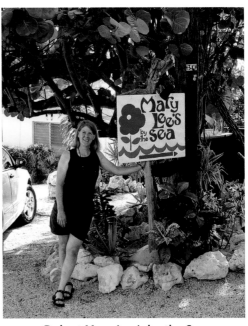

Deb at Mary Lee's by the Sea

could walk right out our door and onto a long wooden dock that jutted past the mangroves into the warm waters of the Caribbean Sea.

As Deb and I had learned when exploring rainforests in other parts of the world, the best time for herping is after sunset. Since this wasn't supposed to be a strenuous trip, we did all our nighttime herping within two hundred feet of our porch. Over the course of our stay, we saw mangrove crabs, fiddler crabs, hermit crabs, spiny lobsters, jellyfish, sea cucumbers, sea anemones, angelfish, sergeant majors, marine toads, tangs, and several species of small, colorful fish we couldn't identify.

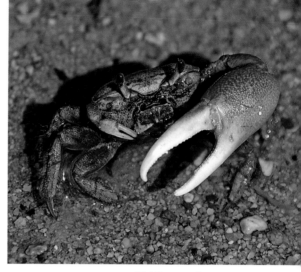

Fiddler Crab

Okay, only the marine toad was a herp. But we found many of the creatures by using the same flashlight spotting technique: hold the flashlight close to your head, and look for eye shine. Besides, some of the colorful crabs were just as cool as any herp—well, almost any herp.

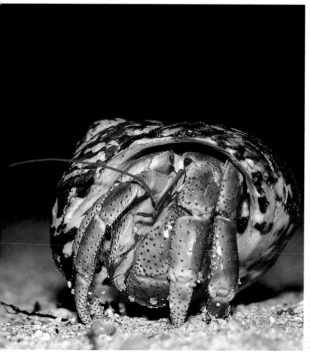

Hermit Crab

Bioluminescent marine plankton (called *dinoflagellates*) and flying fish were two additional creatures that were especially cool. I discovered both as Deb and I sat stargazing at the end of the dock. The dinoflagellates put on a show reminiscent of underwater fireflies. But you couldn't see them at first. The key was to relax your eyes and stare at a single section of water until the show began. As for the flying fish, I found I could coax them into flight by using the beam of my flashlight as a lure.

Days along Puerto Rico's southern coast were only marginal for herping variety. Puerto Rican racers were supposed to be common in the area, but we saw no signs of those snakes anywhere. We did see lizards by the dozens, and heard them rattle through the dry leaf litter by the hundreds.

On one hike, through the Guánica State Forest, nearly every bush had a contingent of tiny lizards scurrying for cover. We also spotted a skink with an iridescent turquoise tail. Unfortunately, it disappeared under the leaf litter before I could photograph it. I was glad to have guaranteed snakes to look forward to. Otherwise, my herping efforts would have been frustrating. Little lizards are kind of like an opening band at a rock concert. The band could turn out to be a great new discovery, but in most cases, you are ready for the main attraction long before the opener leaves the stage.

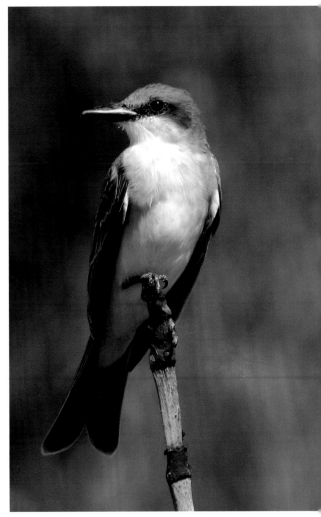

Gray Kingbird

Despite my inability to find any snakes or other large herps, the Guánica State Forest was a fascinating hike, as it contains the largest remaining tropical dry coastal forest in the world (almost ten thousand acres). Because the Codillera Central mountain chain does such an efficient job of blocking rain clouds, the forest receives only

Adelaide's Warbler

about thirty inches of precipitation each year. (For comparison, San Juan, on the opposite side of the island, averages fifty-six inches per year.)

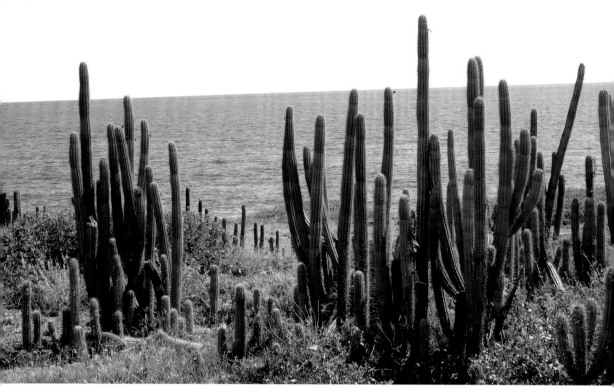

Guánica's dry climate doesn't mean that plant or animal life is lacking, however. Aside from the abundant lizards, the forest also supports seven hundred species of plants and one hundred species of birds. For me, the most memorable sights were the tracts of large cacti that stretched all the way to the beach. And while all the lizards were busy in the leaf litter, numerous small birds flew among the tall grasses and gnarled trees.

Deb and I also engaged in a variety of activities that didn't revolve around a search for reptiles and amphibians. After all, this was supposed to be a girl trip. On one day, we talked our way into a state park that had been closed for the season and went for a peaceful hike along a winding river. Can I help it if my eyes were constantly scanning for herps? Later, we got lost in traffic on the way to a beach, hit a rainstorm, and opted to explore an abandoned lighthouse. Was it my fault its walls were crawling with anole lizards?

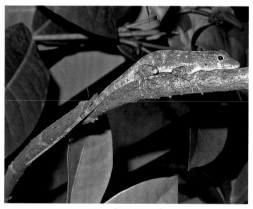

Anole Lizard

After our pleasant stay in southern Puerto Rico, we spent the morning of our last full day driving north across the center of the island. Our journey through the mountainous, moist forest interior was breathtaking—for both its scenery and the frequency of meeting large delivery trucks on the narrow, winding mountain road.

When we popped out on the northern coast, Deb wanted some beach time. Puerto Rico is infamous for its congestion, and when we got caught in bumper-to-bumper traffic near the city of Arecibo, I figured any beach we found would be just as crowded. To my surprise, we discovered a deserted beach three blocks away from the human beehive. Apparently, the overcast sky and relatively cool eighty-degree weather made the beach undesirable for local sunbathers. For Deb and me, however, it was ideal. We spent the

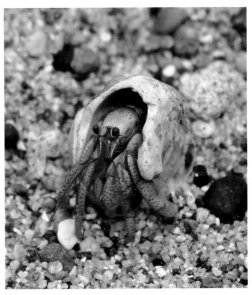

Hermit Crab

next few hours walking the beach, watching hermit crabs, and searching for seashells.

Just before dark, we met up with Dr. Armando Rodriguez, at a bakery in Arecibo, and followed him to the Mata de Plátano Field Station and Nature Reserve. As is typical in Puerto Rico, we traveled from busy traffic to tranquil moist forest in a matter of minutes. Once we reached the field station, and Armando let us through the locked gate, I completely forgot that we were on an overpopulated island, humming with human activity.

As he led us down the path to Culebrones Cave, a hard rain began to fall. The downpour didn't concern me, because I assumed we would soon be inside the cave. When we arrived, my assumption proved wrong. Before us was an oblong pit, roughly thirty feet wide and fifteen feet deep. The pit

dropped straight down in front of a tall rock face, and the entrance to the cave was at the bottom of the pit on the left side.

Descending into the pit would have been difficult in dry conditions. Now its steep sides were slippery with rain, mud, and bat guano. Fortunately, we wouldn't have to enter either the pit or the cave—our first Puerto Rican boa was in sight!

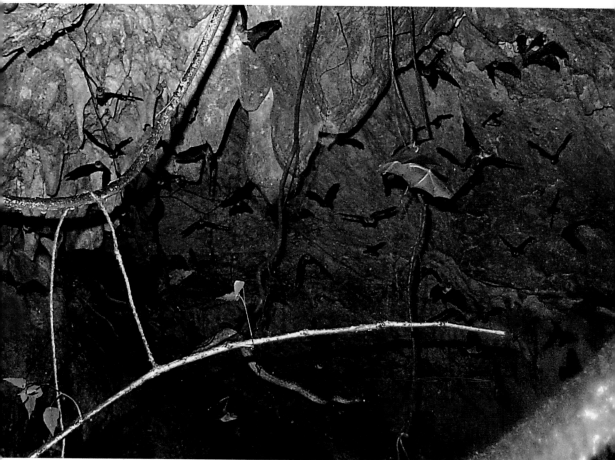

Can you find the Puerto Rican boa?

Deb, Armando, and I swept our flashlights around the pit and counted five boas. Three were hanging from the rock face, and two were clinging to woody vines that crossed in front of the cave entrance.

And then there were the bats! According to Armando, roughly thirty thousand individuals, representing six species, live inside Culebrones Cave. At that moment, they all seemed to be exiting at once. We stood at the edge of the pit as the bats whipped by. Even though we could feel the wind from their wings, they never touched us.

The cave was the snake equivalent of a fast food restaurant. The boa

closest to the entrance stretched from the vine, with her mouth open. Soon she plucked a bat from the air—or one flew into her mouth. I'm not sure which!

Capturing Puerto Rican boas without a permit is illegal, so I couldn't get an actual measurement. However, from where I stood, all the boas appeared to be about six feet long, which is just under the generally accepted maximum length for the species. Ah, the advantage of a reliable food source!

On this night, we observed three boas catching one bat each. Armando stated that on previous nights he had witnessed boas catching and eating as many as three bats apiece.

We may have had guaranteed snakes, but good quality photos were far from certain. The heavy rain forced me to work hard to keep my camera lenses dry, and the darkness made focusing a challenge. I thought back to the days when I used film cameras instead of digital cameras. The rain would not only have made changing film rolls difficult, but opening the camera-back to do so could have also ruined my film, camera, or both.

After a bit, I attempted to venture partway down the pit for a better photographic angle. "Oh, shit!" I screamed as I slipped—skinning my knee and spattering myself with mud and bat guano.

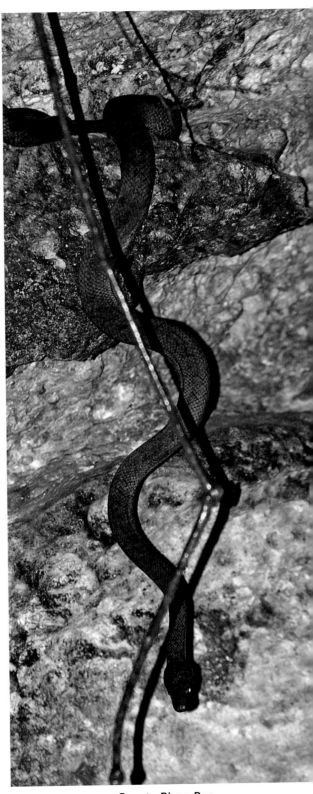

Puerto Rican Boa

Breaking an arm or a leg would have ruined a great adventure. As it was, the bat guano on my scrape made me a bit apprehensive about catching rabies (Armando told me later that as long as I thoroughly cleaned the scrape, and my tetanus shot was up-to-date, I didn't need to worry). With a deep breath, I steadied myself and squeezed off a few shots. Then, cautiously, I climbed back out.

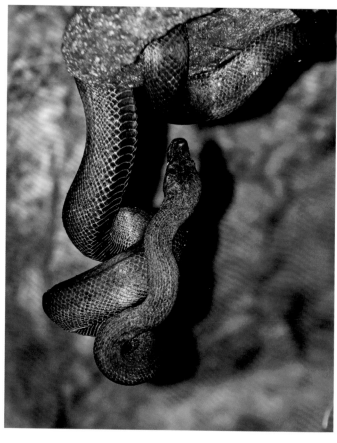

The boas were amazing to watch—especially the ones on the rock face. Somehow they were able to hang onto tiny cracks or ledges with their tails, while their bodies swung free. Several years earlier, in Zimbabwe, a guide had told me that the only time he saw boomslangs (a beautiful snake with a deadly bite) was when they fell out of trees. With that in mind, I asked Armando, "Have you ever seen a Puerto Rican boa fall from the rock face?"

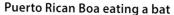
Puerto Rican Boa eating a bat

"Never," he said.

Obviously, the boas were much better suited for the conditions than I was.

Our time at Culebrones Cave passed far too quickly. I would have been content

watching the amazing live nature show all night, but Deb and I still had to find somewhere to eat dinner and drive half the length of the island to our hotel. We thanked Armando for showing us such a special place and headed east toward San Juan.

Later that evening, we arrived at the Ritz-Carlton. Wearing shorts and T-shirts, still damp from the rain and speckled with mud and bat guano, we approached the reception desk. I couldn't help smiling at the contrast between the two of us and the woman ahead of us in line. She was wearing an elegant dress and enough jewelry to support a small mining operation.

When our turn came, the desk clerk scanned us quickly before lowering his head to check his computer screen. "We didn't think you were going to show up," he said, "so we gave your room away."

"We're late, but not that late!" I said, thinking our tardiness wasn't really the issue.

The clerk picked up the phone and made a hushed call in rapid Spanish. I was sure he was going to send us away. Then, he raised his head, smiled broadly, and said, "I have good news! I can give you a complimentary upgrade to a suite."

Moments later, Deb and I stepped into our luxurious, twelve-hundred-dollar-per-night suite and burst into laughter. Had two scruffier-looking people ever graced such a stately collection of rooms?

In the morning, we did our best to dress in clothing appropriate for the Ritz-Carlton and walked across the courtyard for breakfast. After a large, delicious meal, served by a waitstaff that attended to our every need, we waddled back toward our room. Along the way, we stopped to watch an eight-year-old boy standing near a gorgeous four-foot-long, green iguana.

"Pick it up and put it on your shoulder!" said his mother. "I'll take your picture."

Although the iguana was obviously used to seeing humans, it was still a wild animal. I was just about to speak up, and suggest that razor-sharp claws and human shoulders weren't a good mix, when the boy beat me to it. "No, Mom! Are you crazy?"

Once confident that neither boy nor iguana would be harmed, I hurried to our suite and grabbed my camera. I returned to find the iguana alone on a retaining wall, next to one of the tropical gardens. I positioned myself just right and took several photos of the stunning reptile. Unless I mentioned it,

no one would ever know that I had photographed the iguana in the midst of a luxury hotel courtyard—*herpin' at the Ritz!*

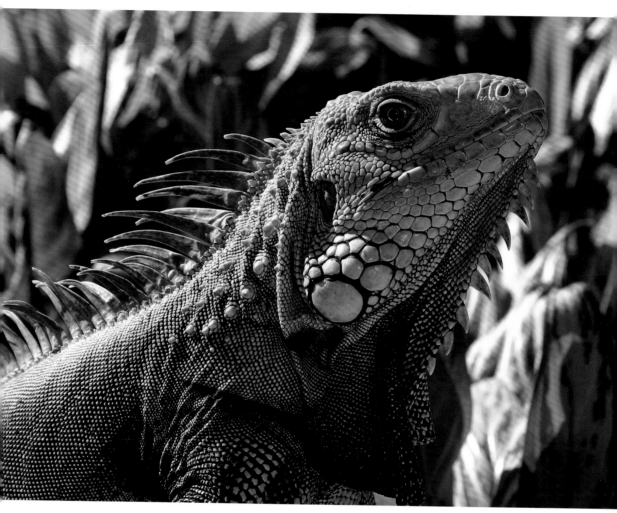

Green Iguana

As we boarded the airplane to begin our trip home, highlights of our stay flowed through my mind. Naturally, I compared Puerto Rico to some of the previous places I had visited. Here's what I came up with: If you're looking for mystique, visit Borneo. If you're looking for species diversity, visit the Amazon Rainforest. If you're looking for seclusion, visit the Yukon Territory. But if you're looking for an enjoyable mix of history, beaches, city life, and wildlife, Puerto Rico is a wonderful place to visit.

As our jet took to the air, I looked out the window, smiled, and said to myself, "Not bad for a girl trip!"

— 2 —

Arctic Eyewitness

────────── Introduction ──────────

Even though this book contains four chapters, sequenced in the order the events occurred, I didn't write the chapters in the same order. In fact, as I'm writing this, the other three chapters are already finished. I held off until March 2015 to start writing this chapter for a variety of reasons.

Deb and I traveled to the Arctic National Wildlife Refuge in June 2008. My goals for our trip were to have an adventure in one of the few pristine regions left in the United States and to increase awareness for protecting that region by featuring it in my next book. The fact that you are reading this now shows that I ultimately accomplished those goals, but things didn't go exactly as planned.

The first delay happened because drilling for oil in the Arctic Refuge was such a hot issue in 2008 (and it still is). Michael Steele famously chanted "Drill, baby, drill!" at the 2008 Republican National Convention and Sarah Palin parroted him in the 2008 Vice Presidential Debate with Joe Biden. Although those chants sounded general, the Arctic Refuge was the first place Steele and Palin wanted those babies to drill. And those two weren't even close to the first politicians lobbying to open the refuge for the benefit of oil companies. Consequently, sometime between the end of our Arctic adventure and Michael Steele's chant, I decided that adding my dissenting voice to the fight via a book would take too long. Fortunately, authors have numerous mediums available to them if they wish to speak out. Instead of a

book, I decided to make my voice heard through a newspaper article about the Arctic Refuge and what Deb and I witnessed in nearby Prudhoe Bay. That article appeared in multiple newspapers from coast to coast.

A second delay happened because the success of my previous book kept me busy speaking at colleges. I'm not the kind of author who can work on a book in his spare time. Once I start, I'm totally consumed by the project.

Yet a third delay occurred because I prefer to write with humor and was having difficulty finding the proper way to tell this story without getting too serious. To my relief, once I started writing the humor came naturally.

Aside from the seriousness of protecting the Arctic National Wildlife Refuge, I also had some serious disagreements with the guide I hired for this trip. Of all the natural places one could visit on our planet, the Arctic Refuge could be the most difficult to visit without a guide. With no roads anywhere nearby, the vast majority of visitors arrive via airplane—a bit incongruous, considering that the refuge doesn't have an airport. Then, once you arrive, Mother Nature—not you—will decide when you can leave. You may plan to depart on a Thursday, but weather conditions, such as a storm or fog, could make rendezvousing with an airplane impossible. Break a leg, have a heart attack, get mauled by a bear—don't count on a quick rescue.

With that in mind, I contacted numerous guides specializing in Arctic Refuge expeditions. The one guide who stood out above all others was Richard (I'm not using his real name, for reasons that will become apparent later). Knowing how important the correct guide would be for this trip, I peppered Richard with a long list of questions. He answered them all to my satisfaction.

The overall cost for the eight-day trip would be twenty-four thousand dollars. That would cover Richard's guide services, food, and transportation between Fairbanks, Alaska, and the Arctic Refuge. Because much of our travel would be via canoe, an even number of participants would be important. Richard and his wife planned to paddle one canoe, and Deb and I planned to paddle another. I then set a goal to find four more people to share in the adventure and expenses.

The first person to join the expedition was Laurel Pfund. (Deb and I had met Laurel in 2003, on a trip to Antarctica. Later she joined us in the Amazon Rainforest. With this trip, she will have traveled to the "ends of the Earth" with us.) The second person to sign up was Mike Holmes. (Mike and I had played together on a men's baseball team in Minneapolis many years earlier.) The third was Conor Black. (Conor is the son of one of my Montana friends, and a former backup quarterback for Harvard University's football

team.) Eventually Mike's father, Mark Holmes, filled the final position. (Although sixty-nine-years-old, Mark was in better physical shape than most men half his age.)

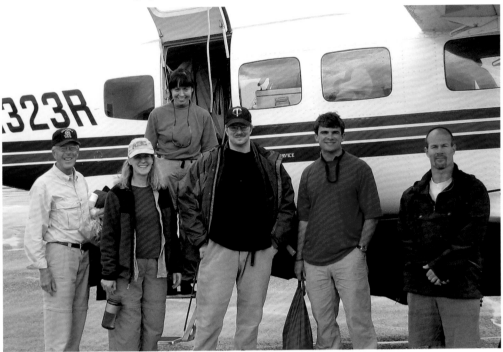

From left to right: Mark, Deb, Laurel, Marty, Conor, Mike
(Photo courtesy of Mark Holmes)

Background

The Arctic National Wildlife Refuge (pro-oil groups prefer to call it ANWR, which they pronounce *AN-wahr*, to make it sound foreign) covers roughly twenty million acres in the extreme northeast corner of Alaska. That seems like a lot, but much of it is mountainous and unsuitable for development. Only seven million acres officially receive the U.S. Government's designation of *wilderness*, the highest level of protection available.

The most important section in the refuge is the Arctic coastal plain, home to two hundred migrating bird species, polar bears, grizzly bears, wolves, musk oxen, wolverines, Dall sheep, moose, caribou, and many other species. Even though 95 percent of Alaska's North Slope is already open to oil development, that isn't enough to satisfy the oil companies and their political allies. They want the "1002 Area," a one hundred-mile stretch of the Arctic Refuge's coastal plain. Oil companies claim they have the technology to drill there without disturbing the ecosystem, but their technology

obviously doesn't work in nearby Prudhoe Bay, where a sickening haze greets visitors, and drilling operations spread out as far as the eye can see (more on that later in this chapter).

Also, oil spills in the Arctic Refuge would be inevitable. According to a study contracted by the Bureau of Ocean Energy Management, the oil fields of Alaska's North Slope have experienced 1,577 spills larger than one barrel, between June 1971 and September 2011. But that fact, apparently, doesn't concern those who value profits and political power more than preserving one of the few places left in the United States unchanged by humans.

―――――― **The Adventure Begins** ――――――

Deb and I left Montana on Wednesday, June 11, 2008, and rendezvoused with our friend Laurel in the Seattle-Tacoma International Airport. There we bought some alcohol (including the all-important, extra-large bottle of Jim Beam whiskey) and continued on to Fairbanks, Alaska.

Shortly after we landed, the three of us met up with Richard and the rest of our group at a restaurant next to the Fairbanks International Airport. Richard was lanky, and his unkempt appearance fit the image of someone who preferred the solitude of Alaska's wilds to the company of people. The first thing Richard told us was that he had a fire in his gear shed the day before, and it would delay the start of our expedition by a half day. The fire hadn't destroyed anything critical, but some of the gear needed cleaning, and his wife would no longer be joining us as planned. Taking her place, as the second guide, would be Adam—a man in his mid-twenties. Although Adam had never been to the Arctic Refuge, he did have prior canoe-guiding experience.

When I had arranged the trip, ten months earlier, our plan was to canoe down the Aichilik River—going south to north—from the Brooks Range to the Arctic Ocean. Now, because of a late ice break-up, Richard was going to lead us down the Jago River instead. The biggest difference for us was that the Jago River didn't have a place for an airplane to land near its mouth. So instead of departing the Arctic Refuge via airplane, we would canoe eight miles along the Arctic Ocean coast to Barter Island, and fly back to Fairbanks from there.

On Thursday afternoon, our group headed over to Wright Air Service to weigh in (Deb's and my combined gear—including cameras, clothes,

sleeping bags, sleeping pads, and a tent—weighed 110 pounds) and catch a ninety-minute flight to Arctic Village. Richard had preceded everyone to the Arctic Refuge, and even though the rest of us departed Fairbanks together, we wouldn't arrive at the same time.

Once we landed on the gravel airstrip in Arctic Village (roughly halfway between Fairbanks and our destination), we transferred to a small charter plane, called a *Helio*. Two Helios were necessary for this portion of our journey. Mike, Mark, and Conor took the first one, while the rest of us waited for the Helio that Richard had taken to return from the Arctic Refuge.

Alaska averages one hundred small airplane accidents and eight fatalities per year, easily leading the nation. Even though flying usually doesn't bother me, I felt a bit apprehensive about our upcoming flight to the Arctic Refuge. Not only would we be in a tiny single-engine airplane, but we would also have to fly over the Brooks Range and land on the tundra.

When our turn came, I took the seat next to the pilot, Ken, and he handed me a headset, so I could listen to any pilot-to-pilot communications. Once we were in the air, the scenery was amazing. First, we flew up a river valley. Then, we started over the mountains.

Deb proclaimed, "This is the best in-flight movie ever!"

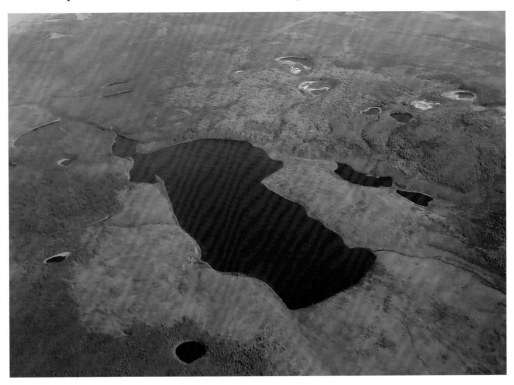

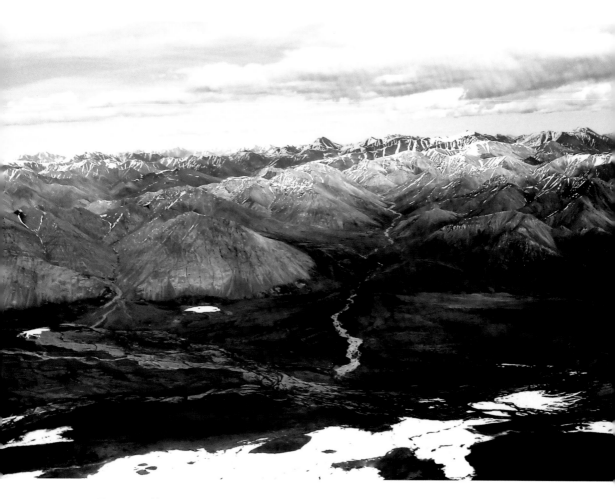

Eventually Ken spotted the other Helio, which was returning from the refuge, and radioed the pilot for a report.

"I almost ran out of engine over the mountains," said the pilot.

"What does that mean?" I asked.

"The wind coming off the ocean was in his face, and he had to fight to keep his airplane from stalling," said Ken.

I tightened my seatbelt and tried not to squeeze the armrest too hard.

Our Helio made it over the tall peaks of the Brooks Range without incident, and the scenery changed to the massive glaciers that feed the rivers, which drop out of the mountains, cross the coastal plain, and dump into the Arctic Ocean. Eventually Ken pointed out the Jago River and piloted us toward the landing area near our first campsite.

I say *landing area*, because we were simply landing on a flat section of ground. Our Helio, however, was equipped with special balloon tires to assist in the task and minimize damage to the tundra.

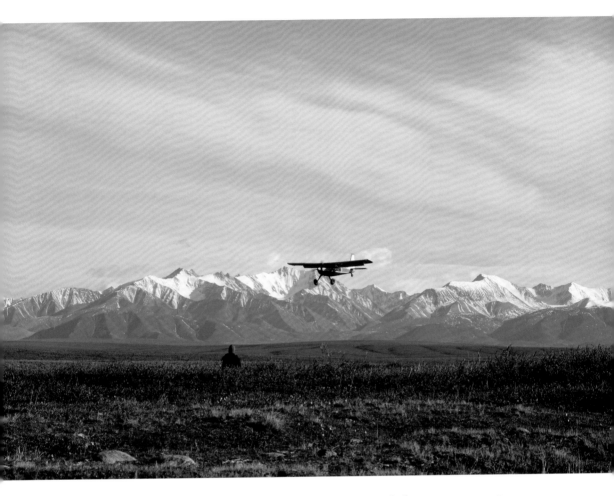

We made it! The Arctic coastal plain is one of the most remote areas in North America. And it felt like it. I looked around and soaked in surroundings unchanged by humans. After all the political fighting and corporate land grabbing, that we still had a place like this in the United States was almost beyond belief. I smiled at the thought that sometimes a strong vision for the future actually does win out over shortsighted greed.

Richard had already set up a tepee, which would serve as the central location for meals and socializing. The plan was to stay at this first camp for a few days before inflating our canoes and paddling downriver.

"Pick any place you want to set up your tent," said Richard. "Oh, and be sure to keep your tent zipped up, or the ground squirrels will get in!"

Snow from the previous winter had melted, but not too long ago. In fact, the gentle hills surrounding us still had snow in places that were shaded from the sun. And, as we would find out later, even though we could walk to the hills, they were much farther away than they looked. Distances were

difficult to judge in such wide-open country. Finding a suitable place to pitch our tent, however, was easy. It wasn't as if we had to compete with dozens of people in a crowded campground.

Deb and I selected a spot near the river and were soon in business. And, speaking of business. . . . Now might be a good time to mention that there are no trees on the Arctic coastal plain, and the already flat land would only get flatter as we got closer to the ocean. The two women in our group would have to seek privacy more often than the men (who could just turn and water the tundra), but sooner or later, everyone would have to engage in what Richard called "free-range pooping."

There was more to free-range pooping, of course, than just hoping we weren't mooning a companion or a satellite looking down from space. To keep the bears from having a disgusting treat, and to stick to our goal of leaving no trace, we burned used toilet paper and buried everything—a job that was often difficult with the ground frozen, just beneath the surface.

Looking down on our first campsite

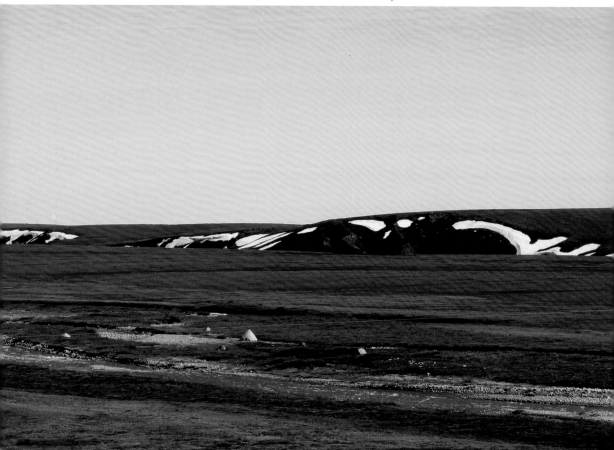

The weather at the beginning of our trip was as good as we could have hoped for. On our first day, the temperature reached into the low sixties, although the wind off the ocean made it feel colder. The following day, the temperature would even be a bit warmer. Our timing was perfect. Summer is short in the Arctic, and the plants and biting insects shorten their cycles accordingly. Already tiny flowers were blooming, and soon—but not quite yet—mosquitos and biting flies would take to the air with an unquenchable thirst for blood.

The biggest adjustment with being this far north at this time of year was that the sun would never completely set. This would be a miserable trip for anyone needing darkness to sleep. I draped a T-shirt over my eyes and slept just fine. What bothered me most was the low angle of the sun, because it always seemed to be shining directly into my face.

One adjustment that happened effortlessly was that our daily meal schedule moved to about four hours later than what is typical for Americans. We'd eat breakfast whenever we woke up, lunch around four, and dinner sometime between nine and ten. The reason for the change was to better synchronize our schedule with the animals and to take advantage of the stunning evenings. No doubt, if we stayed longer, our schedule would have moved even later.

That first evening Deb and I did some exploring around camp. We found moose and wolf tracks, but other than numerous ground squirrels, the only

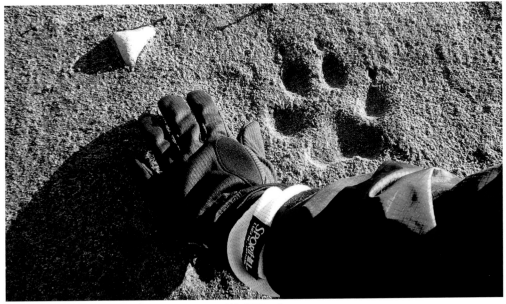

Wolf Track
(Photo by Deb Essen)

mammals we saw were four adult caribou grazing in the distance. One of the many reasons why protecting the Arctic Refuge from development is so important is because the caribou migrate to the coastal plain each year to have their babies. Calving generally takes place between June 1 and June 10, and the female caribou are drawn to the area because during that time the cotton grass is in abundance (which makes their milk more nutritious), and the biting insects are not yet an annoyance. Spotting the initial four caribou was a good sign. With any luck, we would be seeing larger herds, including babies, in the coming days.

Our night concluded with a delicious dinner in the tepee (Richard was an excellent cook) and social time. Most in our group had a silent revolt, however, when Richard asked everyone to take turns doing dishes. Had this been a trip of equal participants, all of us would have gladly helped. Conversely, here, the six of us had paid Richard four thousand dollars apiece, and he had an assistant, Adam, to help him. Over the years, Deb and I have worked with many excellent guides and we knew: when you pay for a guided trip, clean dishes come with the package. Nevertheless, Conor (who was in his mid-twenties and the youngest in our group) opted not to rock the boat and took the first dishwashing duty—making me feel a wee bit guilty.

We woke up in the morning, excited about our first full day in the Arctic Refuge. Already we could see a change, as the glacier-fed Jago River was a bit higher than it had been the day before. Our plans were to hike to the top of a hill, called Bitty, on the opposite side of the Jago. That meant crossing the river, wearing the waders we all brought for the canoeing portion of our journey. The water was a bit above my knees and just fast enough to make me nervous about slipping and dunking my camera.

For Deb, this would be the first of many times she would have problems with her new trifocal glasses. Because she hadn't yet trained her eyes to use them properly, her depth perception was inconsistent. Consequently, her crossing was more of an adventure than it should have been.

As we started up the hill, Richard filled us in on the plant life we encountered, which included Labrador tea, Arctic anemones, Arctic poppies, coltsfoots, louseworts, cranberries, blueberries, and alpine bearberries. To survive the extreme weather and absorb heat, most of the plants were low to the ground (less than six inches tall), with dark-colored leaves.

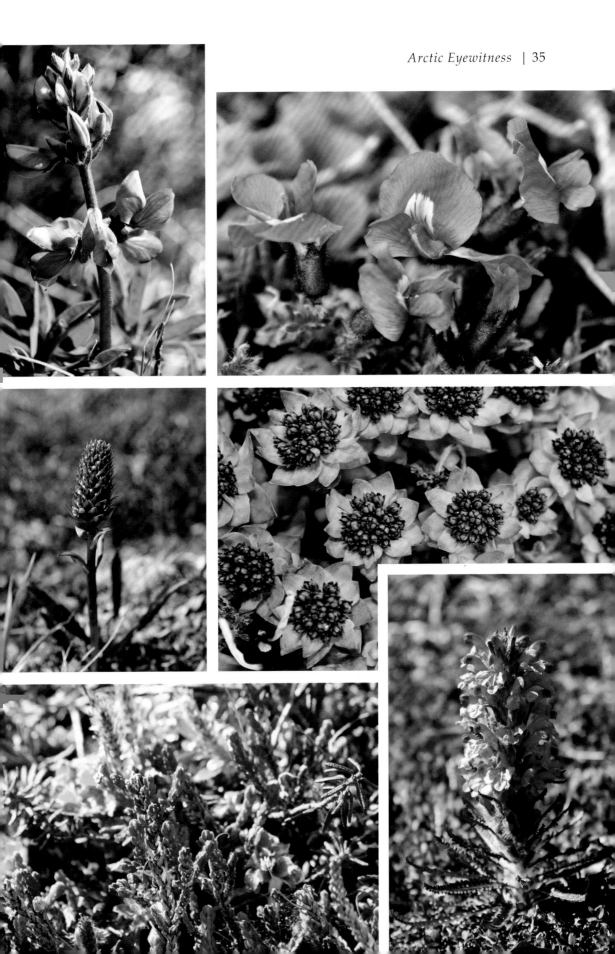

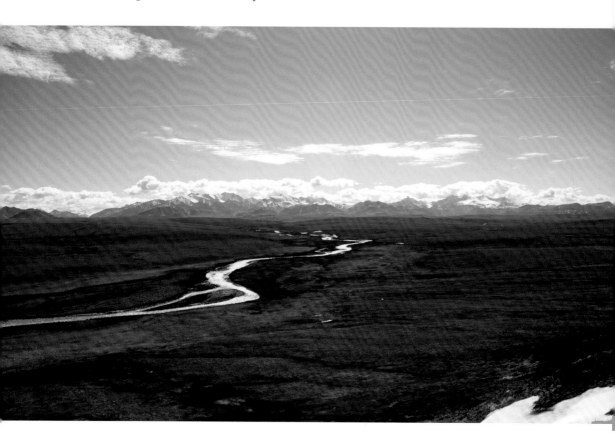

As we climbed higher, we spotted two peregrine falcons, nesting in the rocks under the edge of a cliff, and watched a rough-legged hawk soar below us. Once we reached the top, the view was spectacular. If we looked south, we could see the gorgeous glacier-covered Brooks Range and Jago River zigzagging over the flat tundra. If we looked north, we could see several large tundra-covered hills and the Jago River continuing its journey toward the ocean.

Everyone relaxed, ate lunch, and just enjoyed hanging out atop Bitty. Eventually Mike and Mark wanted a change of scenery and took off on a hike. The rest of us followed, fifteen minutes later.

We were hiking along the far side of Bitty when we had the wildlife sighting of the day. "Bear!" said Deb.

"It's a grizzly," added Richard.

Rapid, hushed conversation ensued as the bear paralleled our position. He was below us—perhaps fifty yards away—and moving fast. I lifted my camera and shot a series of photos. When I put my camera back down, I was surprised to see that Richard had already taken off over the next rise.

I said to Deb, "Okay, the grizzly was cool. But Richard? Not so cool."

The bear obviously wasn't interested in us, but even so, a guide should never leave his clients in such a situation. If the bear had changed his mind, and circled around, additional people would have made him think twice about being aggressive. While I certainly didn't waste time worrying about bear attacks—and we

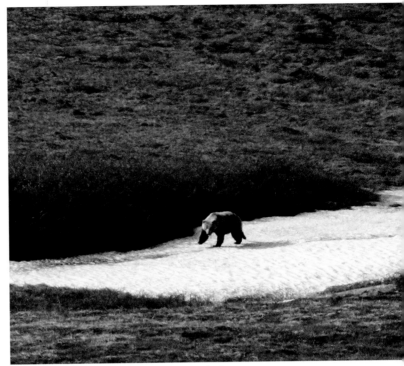

Grizzly Bear

all carried bear spray—more than anything I was shocked, and a little pissed. We all had wilderness experience, but in an area this remote, guides are more important than ever. If the time ever came where we truly needed Richard, would he be there for us?

That evening at dinner, I debated saying something to Richard about the bear but decided to let it go. He was already wound up tight (possibly because of the storage shed fire), and the purpose of the trip was to have fun, not feud. We broke out the Jim Beam, told stories, and declared that since Laurel was now on her third trip with Deb and me that she was officially "Mormon Wife Number Two." The nickname was definitely not PC, but who's PC in the Arctic?

Having Laurel travel with us again was great. She has one of those infectious laughs that goes on forever. If you weren't laughing when she started, you would definitely be laughing by the time she stopped—whenever that was.

On this trip, Laurel and Conor ended up being paired together, as they were the only two to sign up without a partner. Even though they hadn't previously met, they shared a tiny two-person tent. As I found out later,

neither felt awkward doing so, but they slept with their feet at opposite ends of the tent.

As for Deb and me, we went to sleep that night listening to the mating call of a willow ptarmigan.

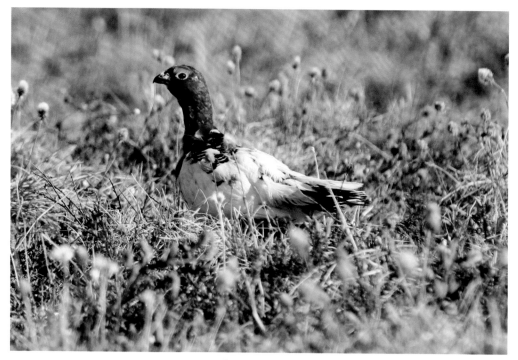

Willow Ptarmigan

After breakfast the following morning, everyone embarked on a hike to the next nearest hill. Although the hill appeared to be something we could reach with little effort, walking on the tundra was difficult, as it was mostly tussock grass, surrounded by spongy lichens and mosses. The idea was to step between the unstable tussocks, as we could sprain an ankle if we stepped on top of them. Deb and I didn't have to go far before realizing that our two-mile tundra trek to the hill would be the equivalent of a five-mile hike on an established trail. But that was okay, we had all day and no one was in a race . . . or were they?

Anytime you get more than a few people together on a hike, some will travel at a different pace than others. Generally, there are two groups: those who go fast and like to cover distance, and those who go slower and like to look around. Neither group is better than the other, and the division of groups is much more dependent on personality than physical ability. Perhaps that is why Deb's and my personalities mesh so well. At times,

we will hike at a brisk pace, but plants, animals, and scenery frequently distract us. For us, the journey is more important than the destination.

With our group, Mike and Mark fit in the distance category, Laurel joined Deb and me in the look-around category, and Conor and Adam bounced in between. As for Richard? He was at the head of the class when it came to speed and distance. Once, when Deb complained, he sheepishly admitted that on a previous trip someone had written "Slow the F Down!" on the toes of his sneakers as a reminder.

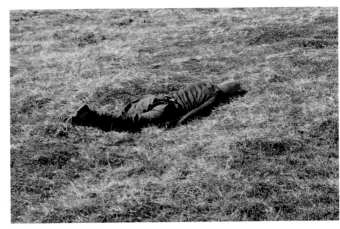

Eventually, we all made it to the top of the hill. There, we ate lunch, and everyone slowed down. Some even took naps. One of my favorite photos from the trip is of Mike sleeping on the tundra. He had found a spot that fit his body like a memory foam mattress, and the positioning of his head and arms gave him the appearance of someone who had fallen out of an airplane and landed that way.

The big difference this hill had over Bitty was that it was higher, and nothing obstructed our view to the Arctic Ocean. However, even without anything in the way, thirty-five miles is a long way to see over land. If we looked through binoculars, we could just make out the ice along the coast.

As for wildlife, we watched a rough-legged hawk do aerial

acrobatics and snuck up close to a willow ptarmigan, but that was about it. Our hike continued across the hilltop, which was broad and seemed to go on forever. When that hill dipped before rising into another, steeper hill, Deb looked at me. "I'm beat. And with my new glasses, I really have to concentrate on my feet."

I glanced to my left, and then turned back to my wife. "I certainly don't need to climb another hill. Let's tell Richard we want to cut down to that creek. If everyone else wants to do the hill, they can do so."

"That sounds good."

After a quick meeting with Richard and the others, we agreed where to rendezvous (the treeless landscape made that task easy), and the two of us hiked down to the creek.

The creek was only a few inches deep, and it would trickle into the Jago River less than a mile from where we were. Deb and I sat on the gravel bar and just enjoyed some alone time. Well, sort of alone. Joining us were redpolls (members of the finch family), which put on an impressive airshow, and numerous sparrows.

When we heard a boulder thunder down the hill, we looked up and saw the rest of our group, high on the ridge. I snapped a photo. It was a classic: everyone was clumped together, except for Richard, who was hiking far ahead of the pack.

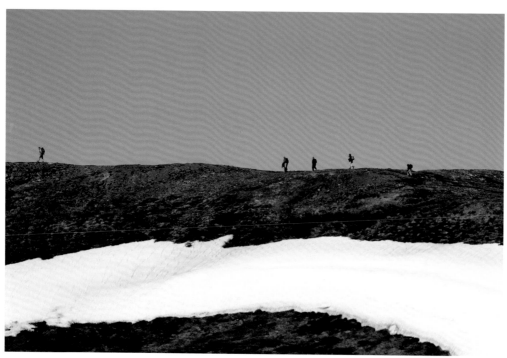

The next morning we struck camp and loaded our canoes. Today would be our first day on the river. Two days ago, when I saw the spot where we would launch the canoes, I wondered if the water would be deep enough for us to float without continually getting hung-up on the rocks. Now the river had plenty of water, and it was moving fast.

We would be paddling SOAR inflatable canoes. SOAR officially stands for "Somewhere On A River," but, of course, paddling enthusiasts say "Sex On A River" instead.

In my pre-trip communications with Richard, I let him know that Mike, Mark, and Conor were experienced paddlers and that Laurel had virtually no experience. As for Deb and me, we both grew up in Minnesota, where we canoed lakes and lazy rivers. When we moved to Montana, we bought inflatable kayaks for paddling the river near our home. Additionally, we had also canoed the Zambezi River in Zimbabwe—narrowly escaping with our lives, when a hippo bit through the middle of our canoe and threw us on shore. Neither of us, however, were advanced paddlers.

Richard had said our varying experience wouldn't be a problem. Nevertheless, we teamed up in the SOARs a bit differently than our sleeping arrangements. We would descend the river in the following order: Laurel and Richard, Mike and Mark, Deb and me, and Conor and Adam.

SOARs are wonderful canoes, and forgiving if you make a mistake. Even so, because of the frigid water and the weight we all carried (personal gear plus group equipment), testing the limits of their forgiveness wasn't recommended, as capsizing would be a disaster.

Whoosh! The biggest rapids of the trip were the first ones we hit. That's not the ideal situation when you're paddling a type of canoe you've never paddled before and have no idea how it will respond with all the weight in the middle. It was intense, but fun! I flashed back to riding the flume at Valley Fair in Minnesota.

Soon after that, Deb and I started having problems. As the river began to wind, we got caught on rocks several times and occasionally had difficulty on some of the bends. SOARS may be forgiving, but they are not precision watercraft (or was it Deb and I who were not precise?).

When we pulled ashore for our first break, we were both frustrated. We sought out Adam, who gave us a quick paddling lesson. "Oh! So that's how you do it!" we repeated several times.

In addition to Adam's tips, this stop was also great for wildlife. We had seen caribou multiple times since we arrived, but they were always far in

the distance. Since we were all hungry, we extended our stop for a lunch break. While we were eating, a female caribou trotted our way. When she saw us, she froze. After a moment, her curiosity enticed her to approach closer . . . and closer. She was almost on top of us when she picked up our scent, turned, and splashed across the river!

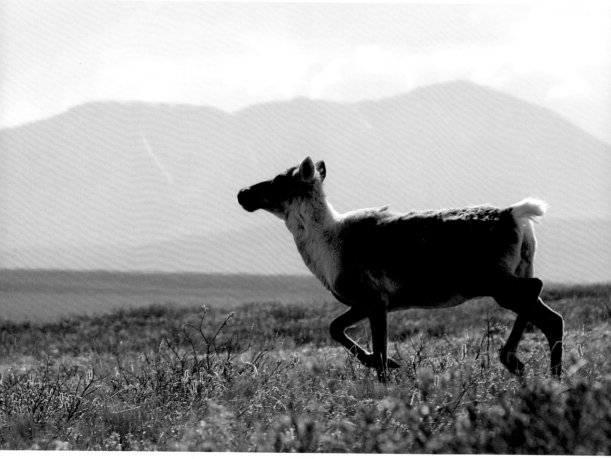

Caribou

Once back in our canoe, I called out the strokes, and Deb and I did much better. That the river had widened and slowed somewhat didn't hurt matters either. But that also created a new problem: the Jago is a braided river (it would occasionally split into two or more smaller channels, merge back together, and then split again), and since no one in our group even knew what river we were going to descend before we reached Alaska, other than anticipating four days of paddling to reach the Arctic Ocean, we had no idea what was ahead.

As Deb and I continued downriver, we encountered channels veering

left and right. Most of the time the main waterway was obvious, but even if it wasn't, all we had to do was follow the two canoes ahead of us. As the day moved on, however, the canoes spread out. We worked hard to keep up with Mike and Mark, and Laurel and Richard, but fell further behind. I started getting frustrated with Deb for not putting more muscle into her strokes, and she started getting frustrated with me for not steering us consistently into the fastest moving current.

We weren't exactly moving slowly, but it was amazing how much faster we moved if we stayed precisely in line with the current. Neither of us read the current well. Deb had her glasses problem, and me . . . well, the sun was in my eyes!

Even so, this wasn't a race, and we were in no way pressed for time. The problem wasn't Mike and Mark, as they were just following the leader. The problem was Richard. Just as he was seemingly incapable of slowing down when he hiked, he was no different when he paddled.

The braided channels (with riverbanks just high enough to block views) made his actions dangerous. Eventually Deb and I found ourselves alone on the river: the two lead canoes far ahead, and Conor and Adam far behind—deliberately going slow. A few times, we had to make channel decisions. What if we chose the wrong channel? Turning around and paddling upstream would be tough. And how would we find the others? We might not even realize we were on the wrong channel for quite some time. Getting everyone back together could be like finding a moving object in a maze—not a pleasant thought in the Arctic.

(Note: Before writing this section of the story, I looked at satellite images of the Jago River. Most of the channels looped back in a short distance, but some extended as far as two miles before rejoining the main waterway. Braided rivers change from year to year, so I can't say for sure how long any of the channels could have been at the time of our trip.)

Eventually we rounded a bend and spotted Laurel, standing on the riverbank. She waved to direct us up a creek, where Richard and the others were unloading gear. We had reached the spot where we would camp for the night.

As soon as we secured our canoe, I stormed up to Richard, knocked him to the ground, and screamed, "What the hell were you doing out there on the river! Don't you ever look back? What kind of shit guide leaves his clients far behind on a braided river like that?"

Okay, that was how my invisible evil twin, Martin, encouraged me to

handle the problem.

What actually happened was that Deb and I decided to hold our tongues until later. We had previously witnessed snippets of the corrosive side of Richard's personality. Had I blown up at him, the way my evil twin wanted me to, who knows what would have happened. A good general rule for far-flung travel is this: never piss off a guide when he's the only one who knows where you are.

Later, when we did speak to Richard, we were able to do so calmly. To his credit, he promised to make more of an effort in the coming days to ensure that Deb and I wouldn't get left too far in his wake.

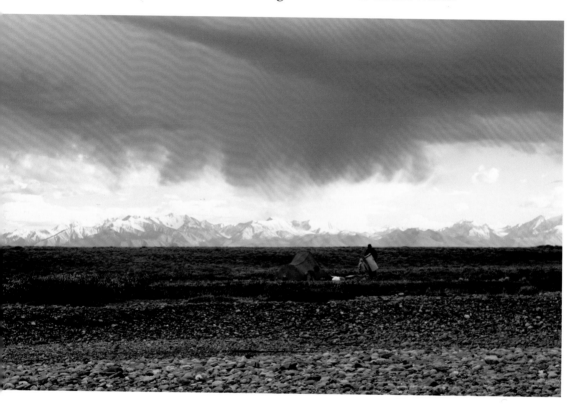

That night we had the best campsite of the trip. We were on a wide, flat section of cushiony tundra, several feet above the river. Richard warned us that from this point on, campsites would likely be rocky, muddy, or both. With that in mind, we did our best to soak in the atmosphere. And there is definitely a special feeling being out on the Arctic tundra that you can't get anywhere else. The Gwich'in Athabascan Indians call the coastal plain the "sacred place where life begins" for a good reason.

Rain and wine accompanied our dinner, and when we moved on

to Jim Beam (or as we called it, "James Beam"), Mark accompanied the festivities on his harmonica. Eventually the rain stopped, and we all piled out of the tepee to enjoy a stunning rainbow. Our day full of mood swings definitely ended on the right note.

In the morning, we got our first taste of uncomfortable Arctic weather. Light rain had drifted back in, and the temperature had dropped substantially. We had a group discussion about whether to stay at camp for the day or keep moving. Mark really wanted to hit the river, and it's hard to insist on being lazy, when the oldest person in your group—by at least twenty years—is raring to go.

The first few hours on the river were chilly, but eventually the weather mellowed out a bit. Our reward for braving the elements was some great wildlife viewing. Birds we spotted included Canada geese, tundra swans, and a variety of hawks. We also saw several small groups of caribou, including the first males of the trip.

Another interesting sight was the permafrost sticking out along the riverbanks. With tundra on top, frosty white ice in the middle, and dirt below, it was almost as if we were canoeing past giant, partially eaten ice cream sandwiches.

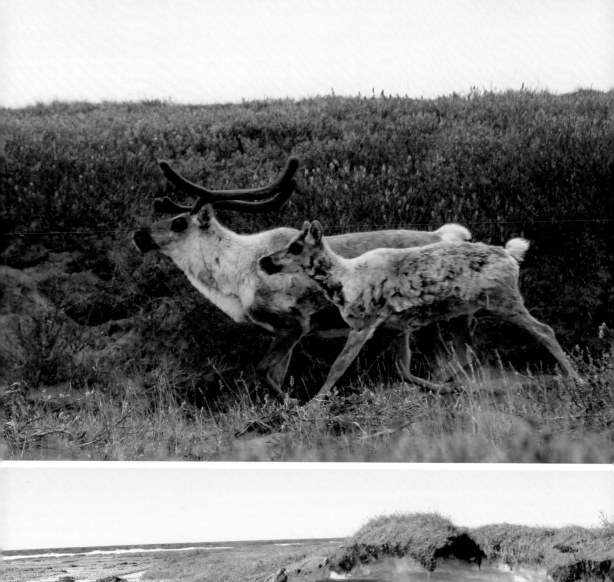
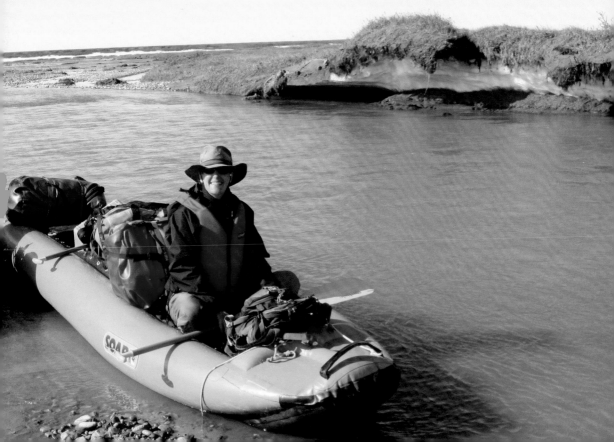

The landscape changed dramatically as we moved closer to the ocean. Already flat land grew flatter, and instead of solid fields of cushion plants (lichens, mosses, grasses, and sedges), the ground was now mostly rocks, dirt, and widely spaced grasses—just starting to green up for the summer.

We set up camp for the night on a silt-covered floodplain. I immediately dubbed the spot "Camp Desolation." Even though the land was flat in appearance, it was just uneven enough to make finding a suitable tent site difficult. Deb and I moved our tent from spot to spot, testing each time to avoid protruding rocks and awkward sleeping angles. Finally, we compromised on a section of ground that was only moderately uncomfortable.

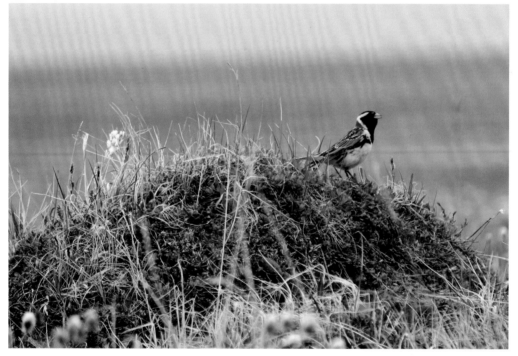

Lapland Longspur

Camp Desolation may not have been ideal for human comfort, but the wildlife sightings made up for it. Aside from more caribou and swans, we added two new birds to our list: a Lapland longspur and a plover. Deb almost stepped on the plover, which was sitting on four eggs in a nest made out of grass and small rocks. The bird immediately feigned a broken wing, trying to lure her away.

Everyone also learned the contents of the mystery box that was in the group equipment Deb and I had been carrying in our canoe: a tiny collapsible woodstove! With the temperature continuing to drop, the woodstove was a

decadent luxury. When we all gathered at ten o'clock for dinner, the tepee was toasty warm.

Tundra Taipan

The next morning began with a laugh. Sometime during the night, Richard had snuck up and placed a plastic snake outside the door of our tent. "Deb!" I yelled. "I finally found a tundra taipan!"

Then, just as we were packing the last few items into the canoes, Camp Desolation gave us a final wildlife present. "Lemmings! There are lemmings over here!" shouted Laurel.

Lemmings are fast little rodents. I picked one out and stalked it. No matter how stealthy I was, each time I got into position for a photo, the lemming darted behind a scrubby bush or a tussock before I could push the shutter button. After several tries, I could see impatience growing in my companions' eyes.

Lemming

"Just one more try. . . . Oh, shit! There he goes again! One more . . . damn! This is the last time. I promise. . . . Aargh! I almost got him that time. Where is he now? Oh, there. I see him. If I can just . . . got him!"

Jago River
(Photo by Deb Essen)

Each day the Jago River widened a little more, and sandbars gradually replaced some of the braids. That also meant shallower waters and more rocks to avoid. Or, in Deb's and my case: hit. Overall, however, we had a fairly low-tension float to the next campsite.

Deb's and my theme for the day was memorable wildlife sightings with no clear photos to accompany them. Our two best happened while we were out on short hikes away from camp.

The first was a male king eider duck that flew away before I could focus my camera. I don't think I've ever seen a more beautiful duck in my life. He had a large black and white body and an elongated head with greenish cheeks, a bulbous yellow forehead, and a bluish gray cap. When Deb mentioned the sighting to Richard later, he said that birders frequently come up to the Arctic Refuge just to find that duck. We felt privileged indeed.

Our second memorable sighting was an Arctic fox. He still had most of his white winter coat, with a little of his brown summer coat coming in on his hind legs and tail. The fox was roughly eighty yards away—too far

for the lightweight zoom lens on my camera. I shot some photos anyway. Mostly though, we just watched, as he moved across the tundra, stopping frequently to mark his territory.

Our campsite that night was a vast improvement over Camp Desolation. We actually had grass again to pitch our tents on. Being closer to the Arctic Ocean, however, meant we all had to work harder to stay warm. Most of us were starting to look puffy from the neck down, as we layered clothes underneath our waterproof parka shells. The bottle of Jim Beam also made us feel a bit warmer, but soon we were going to have to start rationing it like the liquid gold it was.

Our final day on the river had Deb and me gritting our teeth, trying not to blow up at each other. The weather was continuing its downward path toward miserable. Not only was the temperature colder, but a steady drizzle and strong winds had also entered the mix. The low, dense rain clouds really drove home how the Arctic, not its visitors, decides when someone can come or go. Had anyone become sick or injured, outside help would have had to wait.

As for Deb and me, we would never physically injure each other, but on that day, I'm sure our invisible evil twins, Martin and Deborah, were joyfully taking turns holding each other's head under the water. During the two previous days, we had done reasonably well on the river, but now the water had risen and become brown with silt, making the current much more difficult to read. Even worse, paddling into the wind with our inflatable canoe was hard work. The wind seemed to catch the canoe and move it off-course at the worst possible moment. Or was that Deborah doing that?

Whatever the reason, we just weren't working well together. We hit multiple rocks and had a scary moment on a bend, when the canoe got hung-up, and Deb stepped out on the wrong side and stumbled. For a moment, I thought the strong current was going to push the canoe right over her. Fortunately, she backed out of the way just in time.

On the positive side, we were all able to enjoy an amazing animal sighting. Shortly after we pulled onto a riverbank to take a break, Conor spotted a red fox far in the distance. We watched with binoculars, as the fox zigzagged across the tundra, apparently hunting for rodents. She was headed our way—getting closer, and closer. Didn't she see us? Soon she was right in front of us. We all froze as she loped by, cut across a shallow channel, and disappeared over a hill. At no time did she acknowledge our presence.

Red Fox

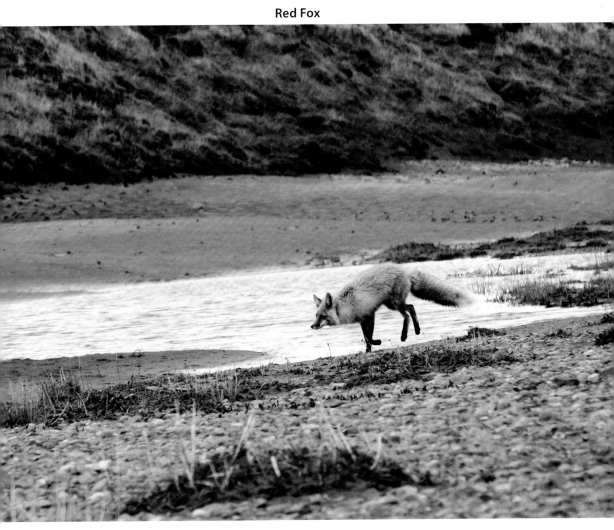

Our final camp was a half-mile from the Arctic Ocean. Once we unloaded our gear and set up our tent, Deborah and Martin returned to the ether, and Deb and I grabbed hands and went for a short walk. One thing we discussed was the coming day. The Arctic Ocean was the biggest unknown of our trip. We would have an eight-mile paddle through the Jago and Kaktovik lagoons out to Barter Island. And if the weather were anything like it was today, the waves would be rough.

I asked Deb, "Would you mind if we switched partners? You could go with Adam, and I could go with Conor. That way we will both be with a more experienced paddler if we hit a bad stretch of water."

"I was thinking the same thing," she said.

The Arctic is not a place to let one's ego get in the way.

The two of us briefly returned to camp. Our new location had something we hadn't experienced since our initial two days in the Arctic Refuge: hills. Most of the hills were small and sandy—obviously pushed into place by previous floods and ocean storms. We joined up with the rest of our group and hiked north to explore the new terrain and get a peek at the ocean.

Along the way, we found fox, caribou, and ground squirrel tracks, and a pond with two water birds: a common loon and an oldsquaw. When I

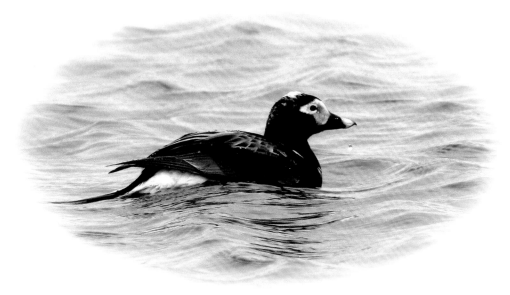

Long-Tailed Duck

pointed out the oldsquaw to Mormon Wife Number Two, I thought for sure the PC police would storm the shore. Fortunately, everything turned out okay—because the offenses were only temporary. As soon as Mormon Wife

Number Two headed home, she would once again become the ardently independent Laurel Pfund, and because of the ongoing elimination of derogatory Indian names, oldsquaws were in the midst of a name change to *long-tailed ducks*. And even though I poke fun at political correctness (when it reaches the point where you have to check a list before laughing), the elimination of derogatory Indian names is something I fully support.

After dinner and social time, Deb and I went for another walk—this time heading south. As we strolled along the river, the wind disappeared and the clouds moved off. With nothing to block its rays, the low sun bathed us in a warm glow and projected long shadows of our bodies on the opposite riverbank. Colors everywhere intensified: the tundra became the goldest of golds and the river became the bluest of blues. We stood there, soaking in the sights and emotions of the moment—willing them into a special spot in our minds, where we would remember them forever.

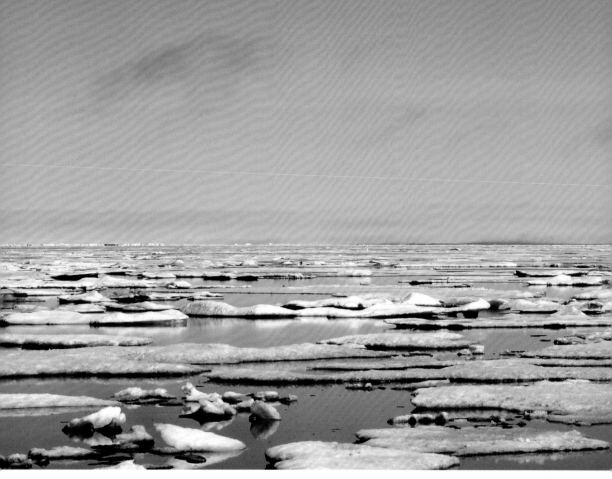

When we got up the next morning, the winds were still calm. We were in luck! For a brief moment, I considered suggesting to Deb that we forget about switching partners, but Arctic weather can change in a flash, and I was looking forward to spending some time with Conor.

The Jago River was about a third of a mile wide when we entered the ocean, and for the first part of our paddle, the water was shallow enough to hit bottom on a normal stroke. The ocean was glass smooth! Had it been rough, we would have had to paddle near shore, but now we could take a more direct route, cutting northwest across the lagoon, toward Barter Island.

Although I knew his father, I hadn't met Conor until we shook hands the day we all arrived in Fairbanks. Quiet and good-looking—he's the kind of person that most people find instantly likable. We quickly coordinated our paddle strokes and effortlessly kept up with the others—talking the whole way. One thing I was curious about was his football career at Harvard University. I learned that in 2000, as a freshman, he completed all four passes he threw. He might have started as a sophomore, but he walked away from the game, deciding he wanted more out of college than just football. So Conor will always be in the Harvard University record books

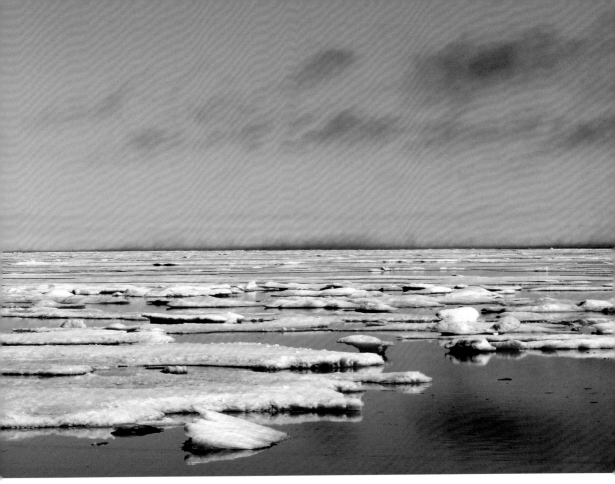

as the quarterback with the all-time highest completion percentage.

Eventually the water deepened, and we all paddled across open water—occasionally passing stray chunks of low-floating ice. Three miles into our journey, we pulled ashore on a small gravel-covered island. There we got out and explored for a bit. The desolate island was home to some common eider ducks and our first sign of human activity in a week: two tall wooden towers, built by the Inupiat as part of their whale hunting operations.

The recent ice break-up on the opposite side of the island took my breath away. Like puzzle pieces randomly laid out on a table, flat, white, oddly shaped ice chunks floated on calm, sky blue water—all the way to the horizon. Canoeing between the chunks of ice would have been difficult. Fortunately, the ice marked the northernmost edge of our journey. From the island, we would paddle five miles directly west, to Barter Island.

We made the entire eight-mile-long paddle in just over four hours. As we pulled our canoes onto land, Richard commented, "Smooth water like we had today happens maybe three times a year."

The Inupiat town of Kaktovik (population 239) sits on the northeast side of Barter Island. There we would be staying at Waldo Arms—a thirteen-

room hotel constructed entirely out of linked-together shipping containers. Since we came ashore just a few blocks away from Waldo Arms, everyone settled into the hotel quickly and enjoyed long, warm, decadent showers. And what was that near the bottom of my dry bag? The bottle of Jim Beam—and there was still some left! Well, not for long.

Later, we learned that a polar bear had recently walked through town. The bear had moved on, but if we headed over to the spit of gravel between where we came ashore and the airport, we could find the bear's tracks. Laurel, Deb, and I did just that. I photographed one of the tracks in the gravel, but no one would have been able to tell how huge it was without something to compare it to.

"Let me put my hand next to it," said Laurel. That did the trick.

"Look at that!" said Deb, pointing behind us.

We turned to see the Kaktovik Lagoon, where we had been paddling just a few hours earlier. The wind had returned, and now angry waves were splashing the shore.

"Whew! We timed that just right." I said.

Feeling fortunate—both for the opportunity to see the polar bear

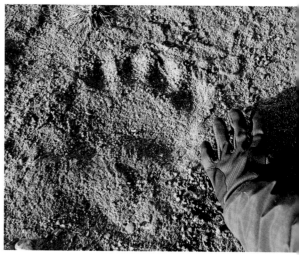

Polar Bear Track

tracks and for our luck in avoiding the waves—the three of us walked back to Waldo Arms. There we joined the others for drinks and talked into the night.

Before we move on to the next section of our journey, I want to share with you part of what I read on a U.S. Fish & Wildlife Service poster mounted on a wall inside Waldo Arms:

"It was visionary forester Robert Marshall's controversial 1938 proposal for a 'permanent American frontier' that first opened minds to the idea of preserving some of arctic Alaska on a vast, landscape scale.

"Fifteen years later, National Park Service scientists George Collins and Lowell Sumner explored the eastern Brooks Range. Inspired by its natural values, they published an article that launched the campaign to permanently protect the area: *Northeast Arctic: The Last Great Wilderness.*

"Wilderness Society President Olaus Murie and his wife Margaret took the lead. They were joined by other prominent conservationists, including scientists Starker Leopold, Frank F. Darling, Sigurd Olson, and Stewart Brandborg, Supreme Court Justice William O. Douglas, and Wilderness Act author Howard Zahniser. The activism of these and thousands of other conservationists through a hard-fought campaign led to establishment of the Arctic Refuge in 1960.

"Few of those who wrote, spoke, and testified for the area's preservation had any notion of journeying to its remote expanses. Then, as now, only a small minority of its supporters planned to backpack, camp, hunt, or raft within it, or even catch a first-hand glimpse of its wildlife or scenery."

If you are interested, you can read the rest of the poster's text at www.fws.gov/refuge/arctic/legacy.html. I have copied the above section here, because it seems like a fitting way to say "thank you" to a group of environmental activists who can never be thanked enough for their efforts. We have major national holidays for various heroic people and organizations in our country, but not one for heroic environmentalists. That's a shame. As for me, I have been fortunate enough to meet two of the people mentioned on the poster: Sigurd Olsen (whom I met when I was an eighth grader in Minnesota) and Stewart Brandborg (with whom I still occasionally converse, as he lives in the same Montana valley that I do).

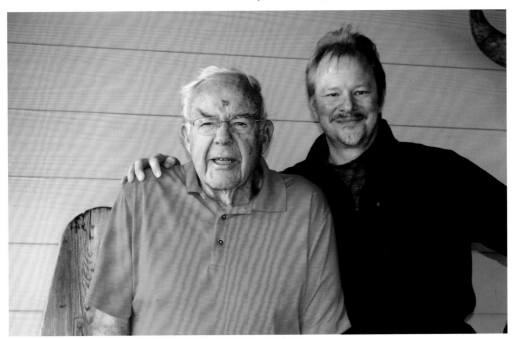

Stewart Brandborg and Marty Essen, April 2015

The next morning we all said good-bye to Richard (who would be staying behind for another expedition) at the Barter Island LRRS Airport and boarded a chartered airplane that would transport us directly to Fairbanks. Well, not quite directly.

"Can you fly us over the Jago River?" I asked.

At takeoff time, the wind was blowing as hard as it had during our entire trip. In fact, I've never experienced a takeoff in any airplane with the wind blowing so hard. And we were in a single-engine plane, just big enough for the seven of us and our gear. That we didn't flip-over on takeoff was a tribute to our pilot's skill.

Soon we were over the Jago River, following it south, toward the mountains. We all plastered our faces against our windows, calling out landmarks along the way.

"There's Bitty!" said Deb.

"Look at all the caribou!" said Mike.

"There must be hundreds of them," added Mark.

"Maybe thousands," said Conor.

The caribou herd was just south of our first campsite. Naturally, we all wondered if they had recently arrived or been there the entire time.

As our flight continued over the Brooks Range, I could feel gusts of Arctic Ocean wind pushing us higher. At first, the feeling was a bit unnerving. Then I realized how much safer it was to be in an airplane that was working with the wind instead of against it. Before long, the cabin grew quiet, and most of us dozed off.

Bitty

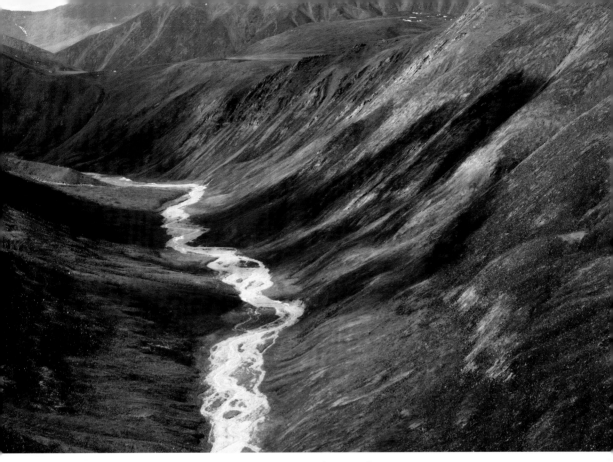

Above: The Jago River in the Brooks Range
Below: Flying south over the Brooks Range

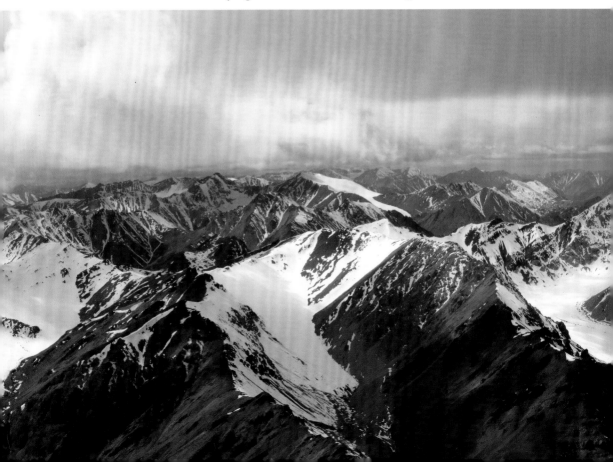

We landed in Fairbanks before lunch, on Friday, June 20. From here, our group would disperse, and Deb and I would rent a car and drive to the Prudhoe Bay oil field. But before that happened, we all had plans to get together and attend the world famous Midnight Sun Baseball Classic that takes place every summer solstice.

The Alaska Baseball League is one of America's great collegiate independent leagues (players must have one year of college baseball experience and at least one year of NCAA eligibility left), as it has helped launch the careers of numerous major league players. The Alaska Goldpanners are one of the teams in the Alaska Baseball League, as well as the annual host of the Midnight Sun Game. For that game, however, the rules are relaxed to allow famous alumni to participate.

This year's famous alumnus would be sixty-one-year-old, former Red Sox pitcher, Bill "Spaceman" Lee. Although I've never been a Red Sox fan, I was a Spaceman Lee fan in my teens. Players who are outspoken, or are true characters, are always favorites of mine. And during his prime, the Spaceman was as famous for his mouth as he was for his talented left arm.

After everybody checked into their hotel rooms, we had some time to kill, so Conor and I decided to walk over to Growden Memorial Park to buy Midnight Sun Game tickets for everyone. Once we had our tickets, we snuck inside the stadium to have a look around. The field was beautiful, and the stands were old-fashioned but in good shape. All in all, Growden Memorial Park had the feel and appearance of a lower-level minor league park. Eventually we walked down a flight of stairs to leave. I was in front of Conor, and as soon as I turned the corner, I saw a man walking my way. He was accompanied by television reporters.

"Quick, Conor! Follow me!" I said.

We raced back up the steps and grabbed seats in the empty stands. Moments later, the man and the reporters entered the stadium—one flight of steps closer to home plate than we were. The man looked out over the stadium, spotted Conor and me—nonchalantly seated—and walked over to us.

He reached out, shook my hand, and then Conor's, "Hi! I'm Bill Lee!"

"Glad to meet you! I'm Marty and this is Conor. We just returned from the Arctic Refuge and bought tickets for the game. How many innings do you plan to pitch tomorrow?"

"I'm not sure," he said. "I'm going to go as long as I can."

We made small talk for a few minutes, before Bill led the reporters

away. Then, trying to look cool, Conor and I calmly left the stadium and rushed back to the hotel to tell everyone, "We met the Spaceman!"

The next night did not disappoint. In front of the second largest crowd in 103 years of Midnight Sun Baseball games (4,900 people), Bill "Spaceman" Lee pitched 6 innings (allowing 4 runs) to lead the Alaska Goldpanners to a 10-6 victory over the Southern California Runningbirds. And, as is the tradition, the game continued until well after midnight, without the use of artificial lights.

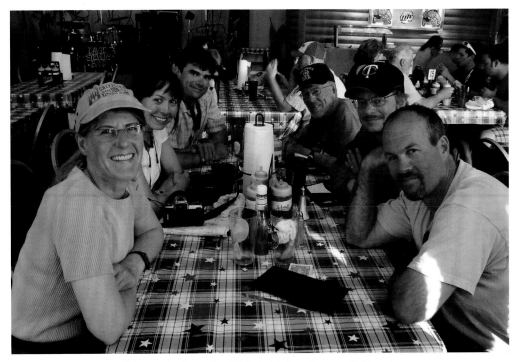

Dinner before the Midnight Sun Baseball Classic

The morning after the baseball game, Deb and I were up early to begin our 495-mile drive to Prudhoe Bay. Although the main purpose of the trip would be to document the stark differences between the Prudhoe Bay oil field and the Arctic National Wildlife Refuge (the oil field is just 120 miles west of the Jago River), we intended to have some fun as well.

Our first order of business was to pick up a rental car at Arctic Outfitters. Because 414 miles of our drive would be on the remote, mostly gravel Dalton Highway, we couldn't just go to any car rental company and pick up just any vehicle. We had to get a car specially equipped for the journey (CB radio, extra spare tire, first aid kit, etc.). And, as we soon found out, a car already lovingly used—with a rock-chipped windshield and various minor quirks,

such as a gas gauge that wouldn't go all the way to full and a continuously lit "check gas cap" light.

Once we got our gear loaded into the Ford Taurus, we headed north up the Elliot Highway. Eventually we veered onto the Dalton Highway, which alternated between pavement and gravel for a bit, before becoming just gravel. The Dalton Highway parallels the Alaska Pipeline and serves as the supply route for the Prudhoe Bay oil field. (It is also one of the roads made famous by the television show *Ice Road Truckers*.)

Our drive was uneventful until our first bathroom break. Of course, with no facilities anywhere, this just meant pulling off to the side of the road and doing our thing.

It was a trap!

Earlier I had mentioned how we had timed our Arctic Refuge trip perfectly to avoid the first mosquito hatch. Our timing wasn't as good this time. Hordes of mosquitoes materialized as soon as human flesh was exposed. We rapidly completed our bodily needs and dashed back to the car with sprinter's speed—slamming the doors as clouds of mosquitos plastered themselves against the windows.

From that point on, if we got out of the car, we would either apply bug dope first or wear our lightweight parkas. Mostly, though, we just drove. The Dalton Highway is not a road you take fast. The rough gravel bites into tires, and aside from the Alaska Pipeline being a constant companion, the rolling hills, bogs, streams, and trees (mostly stunted aspen and black spruce) made for a pretty drive.

We did make three stops, however: one to get a close-up look at the Alaska Pipeline; one to take a photo of Finger Mountain (yes, the rock formation looks like it's flipping you the bird); and one at the Arctic Circle crossing (which is the southernmost latitude where the sun stays above the horizon for twenty-four hours

on the summer solstice and stays below the horizon for twenty-four hours on the winter solstice). After spending a week north of the Arctic Circle, crossing the line of latitude at 66° 30'N wasn't a big deal, but the location made for a good photo opportunity, and we needed a rest break.

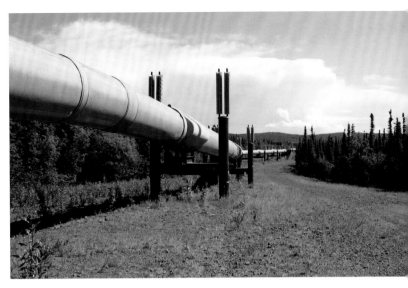

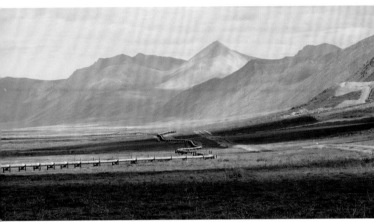

By late afternoon, we reached our destination for the night: the community of Wiseman. There we stayed in one of the three Arctic Getaway cabins owned by Berni and Uta Hicker. Our log cabin was rustic and cozy—a perfect place to relax for the evening.

While we were there, Deb and I took a stroll through Wiseman. Only seven families live in the community, so we didn't have to walk far. What we noticed, however, were solar panels, multiple windmills, and even a waterwheel. The people of Wiseman live totally off the grid. How ironic that we would encounter such a great example of renewable energy creation on our way to a complex dedicated to feeding America's massive fossil fuel addiction.

Arctic Getaway Cabin
(Photo by Deb Essen)

The next morning we continued toward Prudhoe Bay. Soon the scenery changed from just pretty to spectacular. We were now driving through the Brooks Range, with a section of the Arctic National Wildlife Refuge just off to our right. The highest point on our journey would be Atigun Pass (4,739 feet), which is the only pass in the Brooks Range crossed by a road.

"Sheep!" yelled Deb.

I quickly steered to the shoulder. On the mountainside was a herd of nearly thirty Dall sheep (lightweight relatives of bighorn sheep, with all-white coats). We climbed partway up the mountainside for a better view. Just as we were reaching a spot that was close enough for easy observation, but not so close that we would disturb the sheep, something hidden above us spooked the herd, and they dashed out of sight.

We decided not to stick around to find out what caused the spooking and walked back to the car.

"We have a flat," I said.

Getting a flat tire on the Dalton Highway wasn't a surprise. What was a surprise was looking in the tire-changing tool kit and not being able to find a jack. (I'll spare you the string of obscenities we both uttered.) Eventually, after emptying the entire contents of the trunk onto the side of the road, we found the jack under the mini-spare tire.

I put our one full-sized spare on the car, shut the trunk, and gave the car a quick once-around. "Does that tire look low to you?" I asked.

We both stared at the left-front tire, wondering if it too was going flat. Not wanting to think about limping up to Prudhoe Bay on a mini-spare, we convinced ourselves that our imaginations were getting the best of us and continued on. The reality of the situation was that the Dalton Highway has very few places to get gas or get a tire fixed, and we were in the midst of a 240-mile section with no services. It was Prudhoe Bay or bust!

Roughly sixty miles from Prudhoe Bay, the landscape became mostly flat, with occasional pothole lakes and pingos (mounds of land over ice that has been forced up by water pressure in the permafrost) visible in the distance.

Ugh! As we drove closer to our destination, a sickening brown haze hovered on the horizon ahead of us. Once the oil field complex was in sight, we gaped at the sprawling expanse of buildings and machinery. Measuring 213,543 acres, Prudhoe Bay is the largest oil field in the United States, and it is just one of many oil fields on Alaska's North Slope.

Next to Prudhoe Bay is the company town of Deadhorse. Only twenty-

Pingo

five people permanently reside in the town, but during peak times, up to three thousand people live there in prefabricated dorm-style buildings. Through Arctic Outfitters, we had booked a room for the night at Deadhorse Camp. We knew ahead of time that we couldn't just drive onto the Prudhoe Bay oil field and look around. The only legal way for us to get inside the gated complex was through an organized tour. We planned to join the tour scheduled for the following morning.

Right now, our goal was to find Deadhorse Camp. How difficult could that be in a town of twenty-five people? We blissfully continued north, scanning in all directions as we went. Most of the buildings were nondescript, and none looked like a $179-a-night hotel. A few times, we had to choose whether to go left or right and just followed our instincts. I looked in my rearview mirror and noticed a security vehicle following us.

"We're in trouble now!" I said with a laugh.

Since the vehicle wasn't flashing its lights, I continued driving until a

security gate blocked our way, a short distance ahead. The security guard got out of his vehicle and approached ours.

"Can I help you?" he said.

"We're looking for Deadhorse Camp. My wife and I have a room booked there tonight."

"I'm not familiar with that place. You may be thinking of the Arctic Oilfield Hotel. If you turn around and head back, it's just a little ways up the road on the left."

I thanked the man and followed his instructions. Soon we spotted the stilted white prefabricated building. It was one of the few buildings in town with a sign out front. We parked the car and entered the hotel.

"Can I help you?" said a smiling young woman.

I smiled back and said, "Hi! We just drove up from Fairbanks, and we're supposed to have a reservation at Deadhorse Camp. A security guard sent us here, thinking we might have had the name wrong."

"No, only oil field workers stay here, and I've never heard of Deadhorse Camp. Why don't you try the Arctic Caribou Inn?"

"How do we get there?" asked Deb.

The woman pointed, "Take a left at the Y, and follow the road until you reach Lake Colleen. Then take another left and drive partway around the lake."

"Thank you," said Deb.

As we turned to leave, the woman added, "I bet you two are hungry. The workers have already gone through the line in the cafeteria, but there are always leftovers. You are welcome to help yourself. No charge."

"I appreciate that," I said. "But I think we'll grab something to eat after we find our hotel."

We returned to the car and followed the woman's instructions. Five minutes later, we found the Arctic Caribou Inn and stepped inside. There I said to the man behind the counter, "Hi! Can you check to see if you have a reservation for Essen? We're supposed to be staying at Deadhorse Camp, but no one in town seems to have heard of it. The last person we talked to sent us here."

The man looked at some papers on the counter and then said, "No, we don't have a reservation for you here. If you're staying at Deadhorse Camp, it's thirty miles back down the road."

"Thank you."

After returning to the car, Deb and I both agreed that Deadhorse Camp

couldn't be thirty miles down the road, as we had seen nothing but tundra there.

Finally, in frustration, Deb said, "Why don't we just call Arctic Outfitters and ask them where to go?"

"They're probably closed by now. But it doesn't hurt to try."

While I waited, Deb walked back into the hotel to find a phone she could use (we had left our cell phones at home). She returned a few minutes later and said with a laugh, "We're only a short distance away. The woman at Arctic Outfitters said to look for an *industrial-looking* building!"

Deadhorse Camp

"You mean like every other building in town?"

Minutes later, we pulled up to an unmarked two-story metal-sided building. Without instructions, we would have never guessed it was Deadhorse Camp. In fact, as we would soon learn, Deadhorse Camp was a hotel only in the most general sense of the word. Most of the time, it served as a dormitory for oil field workers. It was only during the off-season (the summer months) that they rented out unused rooms to non-workers.

A smiling, dark-haired woman greeted us as we entered the building, "Hello, I'm Susan. Can I help you?"

After we gave Susan a quick recap of our adventure finding the place,

she checked us in and asked us to remove our shoes. "With all the oil workers coming in from the field, it's the only way we can keep this place clean," she said.

Susan then showed us to our dorm room and added, "It's not much to look at, but it's comfortable."

"We don't need luxury," I said. "This is just fine."

"Do you know where we can get something to eat?" asked Deb.

"I'm afraid all the workers have already eaten, and the cafeteria is closed for the night. *Hmmm.* We might have some pot roast left in the refrigerator. Why don't you two make yourself comfortable, and come downstairs to the cafeteria in a half-hour. I'll have something ready for you."

After Susan departed, I said to Deb, "Everyone up here is so nice. When we get back home, I'm going to have a hard time writing anything that rips Prudhoe Bay."

"I know. But keep in mind these people are not the oil companies. You'll find a way to separate the two."

We ended our day with a delicious pot roast dinner and a short walk through town. Although Deadhorse was quiet now, evidence of what it must be like during the peak-season was everywhere around us: rows and rows of tracked vehicles and lines of boxcar-like portable housing, mounted on skis.

Deb in our Deadhorse Camp dorm room

We got up early the next morning to get our flat tire fixed, and then hurried over to the Arctic Caribou Inn to catch the bus that would take us on our Prudhoe Bay oil field tour. Before the tour began, a man shepherded us into a conference room to watch a short video.

The contents of the video were no surprise. Aside from some basic information on the oil field, the narrator repeatedly stressed the oil companies' commitment to the environment. I understand the concept—proven effective by Fox News—that repetition can make almost anything seem true, but did they actually think we had arrived at Prudhoe Bay blindfolded?

Following the video, our tour guide checked our IDs, and we boarded the bus. As we headed through the gates, I looked at the other passengers in the half-full seats and wondered why they were here. Were they here to see how much damage the oil companies were doing to what was once pristine wilderness, or were they here because overcoming nature to get the black stuff was exciting to them? While I guessed the latter, this wasn't the kind of tour where anyone disagreeing with what was happening would feel comfortable speaking up.

Back home, oil companies, and the politicians they control, were busy doing everything in their power to convince Americans that drilling in the Arctic was a good thing. And when they drilled, they only occupied a small area. Their basic message was this: "If the government just got rid of those pesky regulations, and let us into the Arctic National Wildlife Refuge, you'd barely know we were there!"

Here, where drilling was actually taking place, the oil industry's footprint stretched as far as we could see. The fact that we were in a tour bus also meant that we were only seeing what the oil companies wanted us to see.

I understand that oil is something we all use, and I wouldn't have been where I was at that moment without oil. What I'm against is drilling in environmentally sensitive areas and the dishonest (but effective) rhetoric oil companies, politicians, and conservative news media spew forth in their well-coordinated effort to delay the United States' transition to renewable energy. Right now, we are capable of significantly reducing our oil consumption. But that won't happen until American voters insist that our politicians and government policies support renewables, not *pollutables*.

The Prudhoe Bay oil field was quite possibly the ugliest place I have ever been in my life. Pipes going here and there and drilling sites—each

painted a different color—dotted the landscape. Overall, to me, the place looked like death.

The grand finale of the tour was a stop at the Arctic Ocean and a chance to earn a Polar Bear Plunge certificate if you jumped into the water. Several people brought swimsuits for that reason. While they got wet, Deb and I took a walk.

"*Ewwww!*" said Deb. "Look at all that black gunk along the shore."

"I know," I said, as I focused my camera on a mother and her two girls in the water. "And they are swimming in it!"

As we continued walking along the waterfront, I took photos of what appeared to be oil-based sludge, although I wasn't going to taste it to find out. This was so surreal. Why would a rah-rah oil field tour take people to such a place and encourage them to swim? Did they think everyone would be so excited about dipping in the Arctic Ocean that they wouldn't notice what they were stepping in when they entered the water? Obviously, that was a rhetorical question.

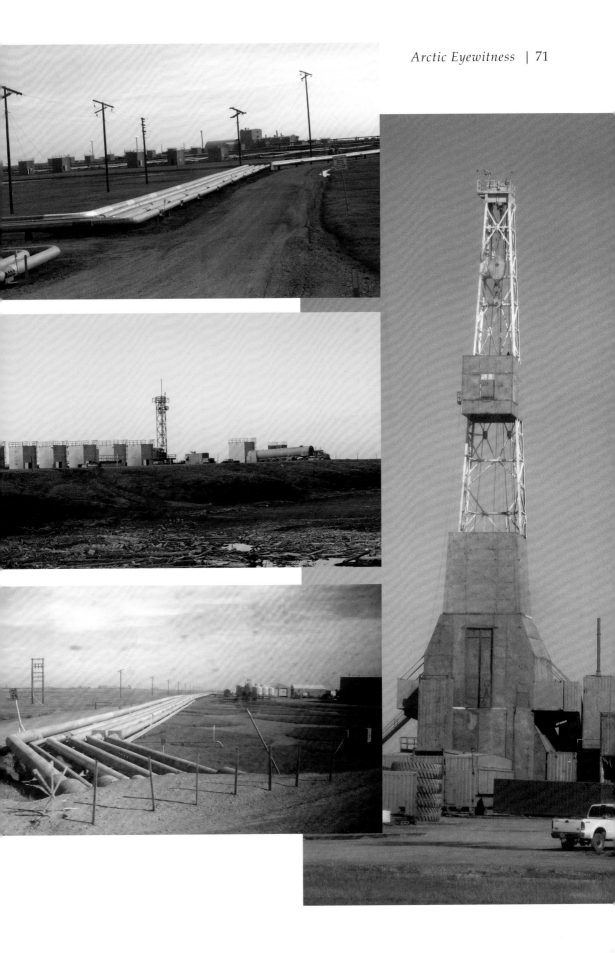

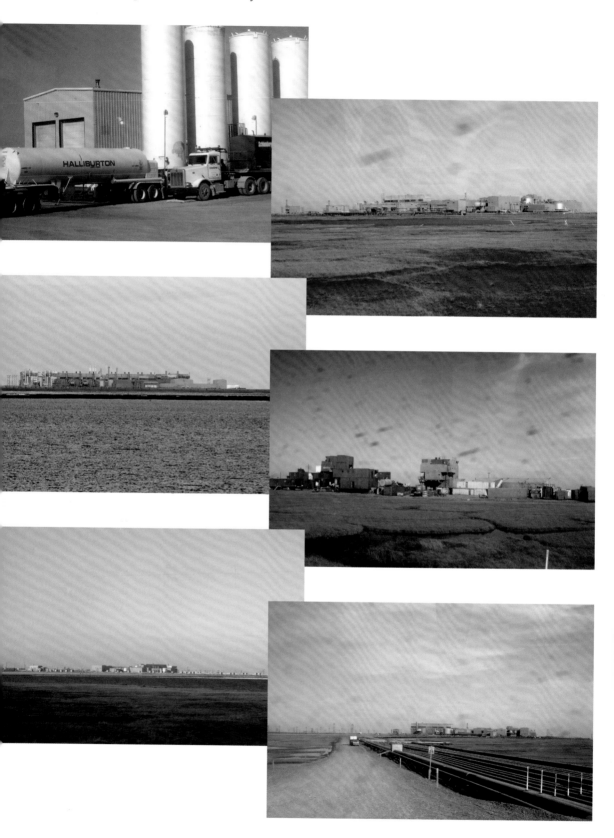

Our tour ended, and we began our long drive back to Fairbanks. After the depressing Prudhoe Bay visit, we needed something to raise our spirits. Fifteen miles down the road, nature came through for us with the first baby caribou sighting of the trip. She was adorable! Adult caribou are somewhat tolerant of human activity (we even saw a few walk through the oil field), but when babies are involved, their behavior changes, and they become much more skittish. In this instance, the mother took one look at us and quickly led her young one away.

Then, later in the day, we pulled off the road and went for a walk that took us up a flower-covered hill. Thin clouds swirled in the deep blue sky, and from the hilltop, we could see for miles over the flat tundra—all the way to the snow-covered Brooks Range. Perhaps best of all, the wind was blowing just enough to keep the bugs away. We sat for at least an hour, enjoying the view and the special feeling that comes with being so far north.

Sharing the hill with us was an Arctic ground squirrel, unconcerned with our presence. When I stretched out on the ground and aimed my camera, he posed for some fun pictures. Eventually we pulled ourselves away and continued on to Arctic Getaway Cabins for another night's stay.

Arctic Ground Squirrel

The next morning, after Uta fixed us a wonderful breakfast, we hit the road and continued south with a minimum of stops. We were almost to Fairbanks when the driver of a wide-load pilot car directed us onto the shoulder. I rolled down my window and exchanged smiles with the man.

"We're bringing a boat up to Prudhoe Bay to go water-skiing!" he chortled.

"It must be a big boat," I said.

"Actually," he said with a wink, "we're bringing the boat up to do the oil exploration we aren't supposed to be doing. Kind of like the pipe we brought up years ago for the drilling we weren't supposed to be doing."

Soon a semi-truck rounded the curve in front of us, pulling an enormous boat that was almost as wide as the road. As it passed, I saw two more trucks bringing up the rear, pushing.

The sight of three diesel trucks pulling and pushing one piece of oil exploration equipment was a fitting microcosm of America's dependence on fossil fuels. It was so backward, so wasteful, and so shortsighted. In the past, the United States led the world in progressive ideas and innovative solutions. Hopefully, someday soon, our country will commit to changing its ways and take the lead again.

Wide Load
(Photo by Deb Essen)

Epilogue

Overall, not much has changed since Deb and I traveled to the Arctic in 2008. Republicans and oil companies are still fighting for drilling access to the Arctic National Wildlife Refuge, and most, but not all Democrats are still fighting to preserve the refuge in its natural state. In fact, two months before I typed this, President Obama proposed to protect 12.3 million acres of the Arctic Refuge as wilderness (the highest level of protection),

and Republican Senator Lisa Murkowski responded by calling his plan a "stunning attack" on Alaska's sovereignty. As *Washington Post* White House bureau chief, Juliet Eilperin, points out, "Democrats and Republicans have fought for 35 years over how to manage ANWR."

So it comes down to American values. Do we value that we still have a special place that looks much like it did before humans arrived, or do we value a policy of doing whatever it takes to fill our tanks with the cheapest possible gasoline? The two values are incompatible.

On the bright side, the Arctic Refuge has survived more than thirty-five years of political fights. If people (including readers of this book) speak out, write letters, and support environmentally friendly politicians, eventually public opinion will evolve to the point that drilling advocates will be seen as nothing more than primitive pariahs. If that happens, the chances are good that the Arctic Refuge of 2108 will look virtually identical to the Arctic Refuge Deb and I visited in 2008. What a great accomplishment that would be!

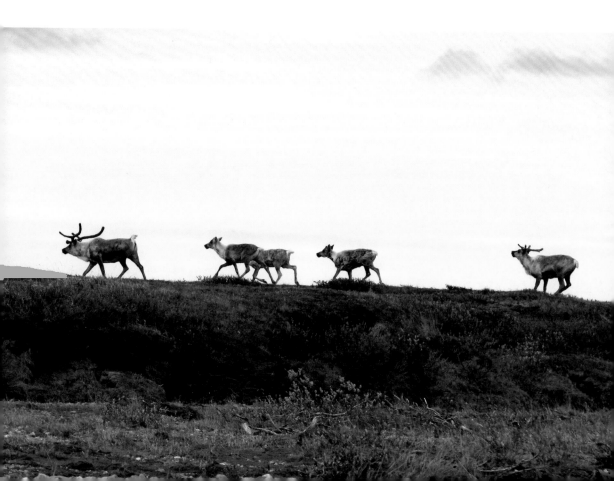

— 3 —

I Got Cottonmouth with Two Russians in the Everglades, but I Swear I Didn't Inhale.

One of my favorite spots in the United States is the Everglades. I had been there once before, with my wife, Deb, and have wanted to return ever since. In late 2013, I had an engagement to perform my show, *Around the World in 90 Minutes*, at Saint Thomas University in Miami Gardens, Florida, and five days before that I had a show at a college in Ohio. Normally such a break between performances would have me frantically working to fill the gap with another booking, so I wouldn't have to sit in a hotel room on the road. This time, however, the gap presented an opportunity. Instead of contacting more colleges, I went online and booked a villa in Everglades City.

Because I had to bring all of my show gear with me (two computers, a digital projector, a wireless microphone system, etc.), I didn't have room to bring my full-sized digital SLR camera. A small pocket camera would have to do. But at least I found room for my hiking boots.

I love photographic challenges, and getting high-quality photos with a little Canon Powershot SX 260 twelve megapixel camera would certainly be a challenge. This would be one trip where I was glad Deb wasn't with me, as getting close enough for my shots would take stealth and patience. Her watching me take pictures would have been the equivalent of me watching her weave fabric. Neither is a spectator sport.

For lodging, I stayed at River Wilderness Waterfront Villas. While not

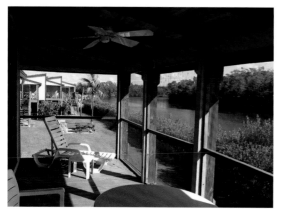

luxurious, my multi-room villa was clean, and you couldn't beat the view of Lake Placid off the large back porch. I will definitely stay there again. But should you follow in my tracks on this adventure, call River Wilderness Waterfront Villas directly. I had booked online through a major travel site and was surprised to see a better direct rate listed at the front counter. I argued for a price match and only got one because I adeptly played my "You Don't Want to Piss Off a Travel Writer" card. Ah, the perks of my profession!

From Everglades City, travelers have lots of options, ranging from fishing trips to canoe rentals to airboat rides. The last time I was here, Deb and I did some exploring by canoe. She, however, has a much better sense of direction than I do. Risking getting lost in the winding waterways of the Everglades didn't seem prudent. And if I missed presenting my college show—on travel adventures around the world—my reputation would take a serious hit.

Instead, this time I would head a bit north and explore by foot—all while concentrating on landmarks that would lead back to my rental car if getting-lost-in-the-woods-willies set in.

Want guaranteed alligators? Drive the Loop Road that circles out and back from the Tamiami Trail (U.S. Highway 41). My wife and I had previously explored the road, and I was excited to do it again. In fact, I planned to spend my entire first day on the twenty-four-mile-long road.

I reached the western end of the road early in the morning and slowly drove south and then east. The dirt road travels through swamp, with crystalline water and haunting cypress trees on each side. For the first twenty minutes, I didn't see anything with a heartbeat. I was beginning to doubt my guaranteed alligators claim when the first one came into view. I stepped out of the car and leisurely approached the three-foot-long gator and—*splash!* He shot into the water. I slunk back to my car, vowing to be stealthier the next time.

My next opportunity was less than a mile ahead—and he was a big one. I gently clicked the car door shut and tiptoed down the road. The eight-foot-

long alligator was on the shoulder, between the road and the water, soaking up the morning sun.

I inched closer.

And closer.

I crouched down.

Soon I was sitting beside him—less than six feet away. I know . . . I know . . . Steve Irwin, "The Crocodile Hunter," is a classic example of what happens when someone gets too close to wild animals, but the gator seemed relaxed and unconcerned with my presence. And if your time is up, it's much cooler to go via alligator than stingray.

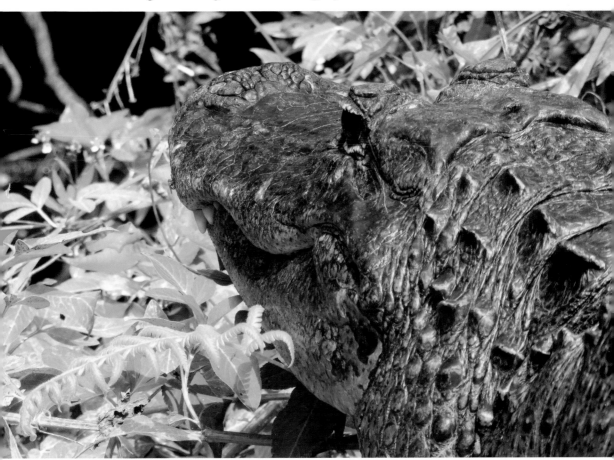

Alligator

What's that! My eyes widened. An Everglades racer was slithering past my knee, heading for the alligator. "This isn't going to end well," I said to myself. But soon the three-foot-long snake was halfway across the alligator's tail, where she paused to look around before continuing on her way.

Although neither snake nor alligator seemed concerned about each

Everglades Racer

other, I had a dilemma. Do I hang out with the gator or follow the snake? I carefully backed off and arced around the bigger of the two reptiles.

Past experience has taught me that snakes—especially small ones—don't stick around when humans are present. This Everglades racer, however, was locked in on a hunting expedition, and seemingly nothing could distract her. Crawling on my hands and knees, I followed the snake as she worked her way through the low-growing leafy plants alongside the road. She was obviously on the trail of something, as she'd stop, flick out her tongue to pick up the chemical scent of her prey, and adjust her path accordingly. (Even though a snake can smell through its nostrils, its forked tongue is more efficient, as it deposits information directly into the Jacobson's

organ on the roof of its mouth.) Sometimes she'd even crawl in a circle, but always she'd return to crawling in the direction she had started.

I'm usually tempted to catch the snakes I find for a brief, up-close examination. This time, however, I was content to merely observe. She was so focused on her task that not only did I feel as if I was on the hunting expedition with her, but I could also take some pretty cool photos at close-range.

Eventually I left the Everglades racer and returned to commune with the alligator. Resisting the urge to make a catch here wasn't a problem either—and I hoped the alligator had a similar resistance to making a catch of his own. Unlike me, alligators definitely do not practice catch-and-release.

By the 1960s, hunting and habitat loss had brought alligators to the brink of extinction. Fortunately state and federal protections enacted in 1967 (this was before the Endangered Species Act of 1973) helped this amazing animal make an impressive recovery. Can you imagine Florida or Louisiana without alligators? The University of Florida "Ground Skinks" playing for the national championship in any sport would be just weird.

Alligators have lived on Earth for between 150 and 200 million years. And although they survived their first major extinction scare from humans, they have another human-caused threat on the horizon. As polar icecaps

Alligator Eye

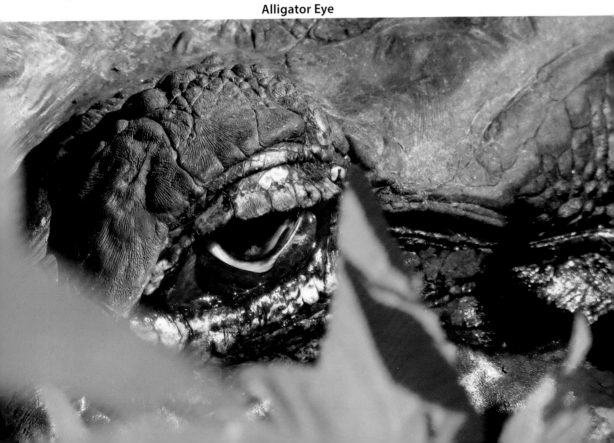

and glaciers melt due to climate change, the rising ocean levels will flood much of their freshwater habitat with seawater. Too bad most of today's climate change-denying politicians will be dead by then. But at least the politicians' offspring will be around to feel the shame of coming from ignorant ancestors, who didn't do something when they had the chance.

In the wild, a typical adult female alligator will reach nine feet in length, and a male will reach sixteen feet. And just like fish, they can grow substantially longer in a good adventure story.

Scientists consider crocodilians, including alligators, to be the most intelligent of the reptiles. Not only can they learn travel patterns of potential prey, but they also occasionally use sticks as tools. Sinking low in

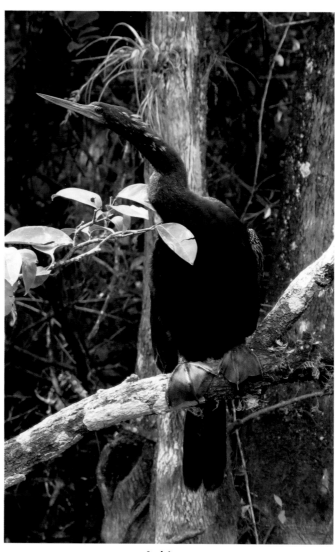

the water, a crocodilian will balance a few sticks on its snout, and when a bird flies down to grab one for nesting material—*wham!* The bird becomes lunch.

Wow! For a lover of reptiles, a day couldn't get much better than this. Or could it? I said good-bye to the alligator and continued down the road. The Everglades supports roughly 50 species of reptiles, 17 species of amphibians, 40 species of mammals, and 360 species of birds. I enjoy all animals, but I must admit that birds have never fascinated me as much as other kinds of wildlife—until recently. What was I thinking? Birds are cool!

Anhinga

Had I been almost anywhere else, photographing birds with a pocket-sized digital camera would have produced little more than small, grainy images. But along the Loop Road (and other nearby places) the tree line was never far away—keeping the birds in range wherever I stood. And sometimes I enjoyed just putting down the camera and observing.

Anhingas were among my favorite birds to watch. The long-necked members of the darter family sometimes perched on low-hanging branches, stretching their necks back and forth in a hypnotic motion, as they enjoyed the sun. On one lucky occasion, an anhinga put on an extended display, just twenty feet away from me.

Little blue herons were another favorite. They could look like two separate species, depending on whether they had their foldable necks pulled in or extended. I hid behind a tree and leaned out to photograph one that was standing in a cypress-knee-dotted swamp. Beautiful!

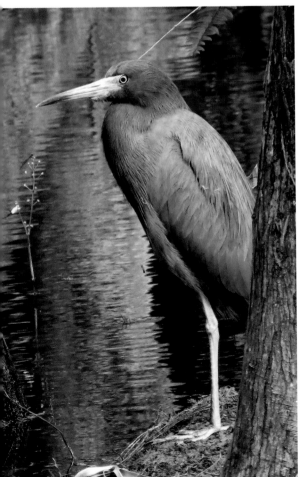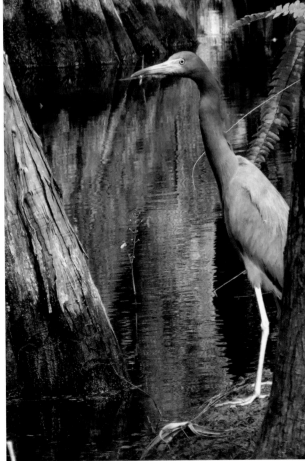

Little Blue Herons

And then there were the great egrets, standing four feet tall, elegantly wading through the shallow water, looking for fish and frogs to eat. Great egrets are another example of the dangers of unregulated hunting. At the end of the nineteenth century, these regal birds were nearly hunted to extinction for their plumes, which were used to decorate ladies' hats. Great egrets are also another example of how effective strong conservation laws can be, as such laws have helped these birds make a strong comeback. For those who rail against government regulations, I ask, "Where would the great egret be today without those regulations?"

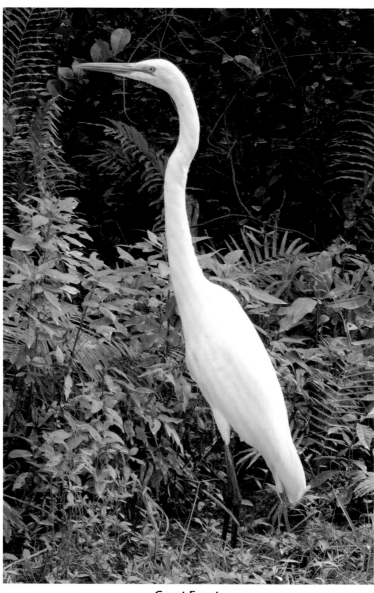

Great Egret

After a great day of alligators, snakes, and birds, I reluctantly turned my car around and headed west on the Loop Road. I stopped several more times to enjoy the wildlife, and was just reaching the part of the road where the landscape opens up and cars pick up speed, when I noticed two people standing in the distance. As I neared, I saw why and quickly pulled to the shoulder. Two young men were taking videos of a cottonmouth with their mobile phones.

The venomous snake was coiled in the middle of the road, refusing to move. I introduced myself to the men and soon learned they were tourists from Russia. They didn't have the slightest idea what kind of snake they were dealing with.

Normally I would never take over someone else's find, but in this case, I had to make an exception to my self-imposed rules of wildlife-spotting etiquette and insist they stand back while I moved the snake. (After informing the Russians that cottonmouths were venomous, they didn't have a problem with that.)

I have years of experience working with snakes, but when it comes to serpents of the venomous kind, I'm no Jeff Corwin or Steve Irwin. Besides, if a venomous snake bit me because of a stupid maneuver, Deb would kill me the moment I left the hospital.

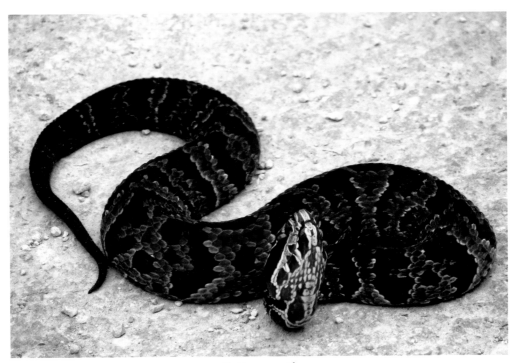

Cottonmouth

So rather than attempt to move the cottonmouth by hand, I planned to use a stick. But could we find a long, sturdy stick nearby? *No-ooo!* I would have to make do with what could best be described as a muscular twig.

Like me, the Russians understood the importance of what we were doing: if the snake remained where he was, he wouldn't last an hour. After a quick photo session, our international rescue operation commenced. With one Russian halting traffic and the other filming the process, I gently tried to move the cottonmouth off the road.

The snake, of course, wasn't happy about this. All he was doing was soaking up heat from the gravel to raise his body temperature for the upcoming cool night, and three giants were hindering his efforts. Whenever I'd pick him up, he'd slide off the twig. The going was slow, and the line of cars was getting longer, but eventually we accomplished the task and celebrated with a round of high-fives.

I'm sure somewhere out there, on the Internet, is the Russian's video of our *Great Cottonmouth Rescue*. Should you ever come across it, please email me the link.

Educational notes: Cottonmouths and water moccasins are the same snake. Although their venom is potent and potentially deadly to humans, the snake rarely bites unless it is stepped upon or harassed. That was something I observed while moving the snake off the road. Although he opened his mouth in a threat display, he never tried to strike me. Unfortunately people still kill cottonmouths out of ignorance, and even kill non-venomous snakes that superficially resemble cottonmouths for the same reason. All native snakes play a valuable part in keeping their surrounding ecosystems in balance. (The same does not necessarily apply to non-native snakes.) So even if you don't like snakes as much as I do, please respect their role in nature and let them live.

The next day I decided to explore somewhere new and headed up the Turner River Road, which goes north, on the opposite side of the Tamiami Trail. While still a dirt road, it didn't have the closed-in feel or slow pace of the Loop Road. Hence, my mixed feelings that were to come. On the positive side, the birds would be spectacular, and I would capture one of my all-time favorite alligator photos. On the negative side, I would have to deal with two armed men in a pickup truck, who I suspected to be poachers.

Where I explored, the Turner River Road was as wide as a two-lane

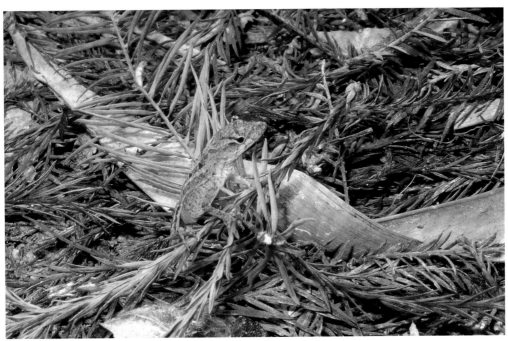

A tiny lizard needs great camouflage

White Ibis

highway. Woods paralleled the western shoulder of the road, and paralleling the eastern shoulder was a strip of tall grass with widely spaced slash pine trees. Beyond the grass was an expanse of open water, which would have been challenging to throw a rock across. On the far edge of the water were tall trees dotted with great egrets, anhingas, and great blue herons. On the near edge of the water, perched in one of the slash pine trees, were black vultures.

They were my first stop. I counted ten vultures in all. Or was it eleven? As I eased toward them, three flew to the ground to give me a once-over. While having a wild animal curiously check you out can be exhilarating, when it's vultures that are doing it, you can't help but

Black Vultures

wonder, "Do they know something I don't know?"

Vultures seldom make a birdwatcher's favorites list, but I thought their mask-like faces showed character. And like snakes, they perform a valuable service for the ecosystems they inhabit.

Kaboom! A gunshot startled me. I looked up just in time to see a man with a gun jump out of a pickup truck and run into the woods. The truck was on the opposite side of the road, one hundred feet away. When the driver spotted me glaring at him, he jammed his truck into gear and sped away.

Knowing that sooner or later the driver would have to come back for his companion, I reviewed my options: I hadn't been able to get the truck's entire license plate number. Should I jump into my car and race close enough to get the rest of it? But did I know for sure the men were doing something illegal? Perhaps shooting and running was normal here in Florida. And if not, did I really want to mess with two armed men on a lightly traveled dirt road? I decided not to do anything unless I saw an obvious crime when the driver returned.

I drove on until I came across a gorgeous great blue heron, wading in shallow water close to the road. This was perfect! I had seen great blue herons on the far side of the water, but achieving a good photograph of them was asking a lot of my little pocket Canon. I exited the car and crept closer. The bird flew away. "Damn!"

In the interest of accuracy, I should now repeat the above paragraph three more times. But to prevent you from thinking that my editor made a terrible error, I ask that you either go back and read the above paragraph three more times on your own, or just pretend that you did.

Then, finally, on try number five, either I had greatly improved my

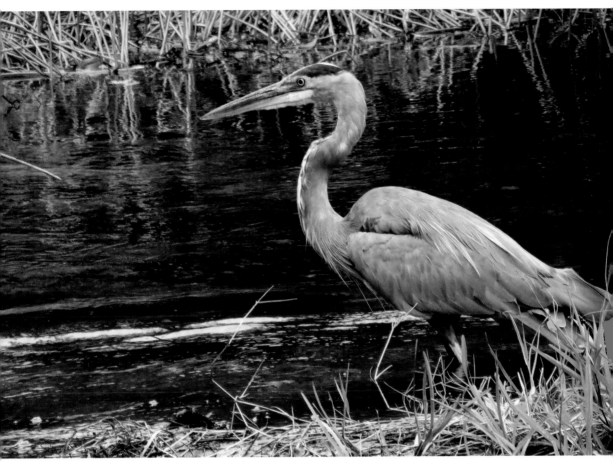

Great Blue Heron

creeping methods or the great blue heron gods had decided to have mercy upon me, because I was able to squeeze off numerous shots before—*Kaboom!*

The men with guns were back. The great blue heron—and pretty much every other bird in the vicinity—took to the air, and soon the truck sped away as well. Then something even worse happened: the song "Dueling Banjos" became stuck in my head. I hummed the hook without pause for the rest of the day.

"Do-do-dooo-do-do-do-dunt-dunt-dooo!"

My next find made my heart sink. It was a beautiful gold and brown Everglades rat snake. She was partway out on the road, and I thought I was going to have to repeat a rescue, like I had with the cottonmouth. Unfortunately, I was too late. When the snake reared up to defend herself, I noticed that part of her lower jaw was missing. An automobile tire had just clipped her. I carried the snake off the road and debated whether or not to put her out of her misery. Then I thought, "If she's got enough fight to

defend herself, perhaps she has a chance to survive." I placed the snake in a sheltered area near a pond and wished her well.

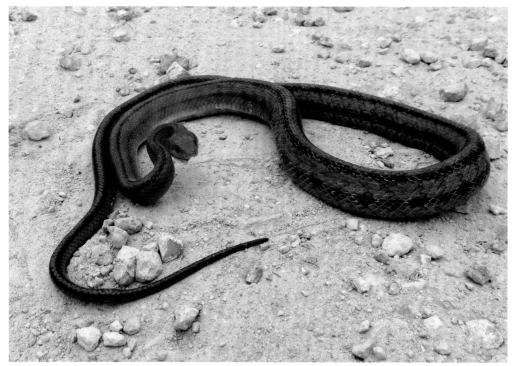

Everglades Rat Snake

Most of the water I had seen up to this point had been clear, but the pond where I released the Everglades rat snake was covered with what looked like slivers of tree bark and other decomposing organic substances. On the near side of the pond, the earth rose straight up from the water, forming a one-foot-high bank. I stood on the edge of that bank and looked out over the water. On the far side were two anhingas, drying their feathers. I snapped a few photos and let my gaze fall between my legs—*Alligator!*

"Don't move," I whispered to myself.

This was perhaps the best camouflage I had ever seen. Only the top of the alligator's head was visible, and it perfectly matched the organic flotsam. I took a deep breath and inched my camera into position. I snapped four photos. Then I leaned over the water, so I could shoot straight down on her head—*splash!*

With a violent flick of her tail, the alligator was gone.

Feeling satisfied with another day full of photographic adventures, I decided to head back for the night. I drove to Everglades City, humming, *"Do-do-dooo-do-do-do-dunt-dunt-dooo!"*

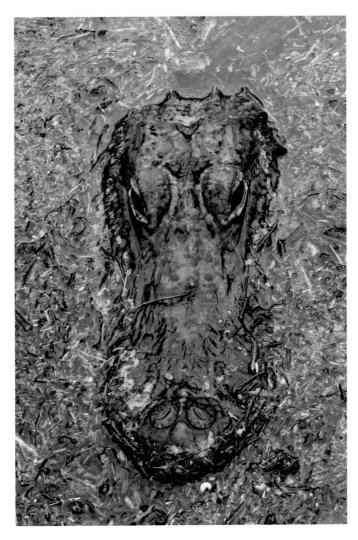

I scoured a map to decide where to go for my last full day in the Everglades and settled on Fakahatchee Strand Preserve State Park. I knew nothing about the park, other than it was fifteen minutes north of Everglades City, and a gradually diminishing road cut through the park until reaching a spot where the map stated, "Travel is not recommended beyond this point." Had Deb been with me at that moment, we would have shouted in unison, "Rental car road!"

I was up early and arrived at the park a few minutes before eight. A sign at the entrance said the park opened at eight, but there were no gates or people in sight. After a moment of hesitation, I drove in.

The Janes Memorial Scenic Drive was exactly what I was hoping for: a narrow dirt road with swamp on both sides. I drove slowly, stopping frequently for birds, butterflies, and alligators. And true to the map, the

farther I traveled, the rougher and narrower the road became. Finally, I couldn't go any farther—a large alligator blocked my way!

I pulled as far off to the side of the road as I dared and got out. I approached to within thirty feet, sat, and watched. *Hmmm.* I scooted up another five feet; and another; and another. I kept waiting for the alligator to hiss a warning or give some sort of sign that I was getting too close. At seven feet, I decided I had nothing to gain and everything to lose if I moved closer. So there we sat—the gator (whom I named "Larry") soaking up the sun, and me soaking up the exhilaration of sharing the road with such a magnificent creature.

Twenty or so minutes passed before I heard a vehicle approach. I looked over my shoulder to see an SUV stop and four park rangers get out.

"I'm in big trouble," I thought.

Instead, the rangers chuckled at the sight. "I'm sorry, but we're going to have to interrupt your breakfast meeting," said one of the rangers. "We have work to do down the road. We'll try to drive around, but I'm pretty sure the

Larry

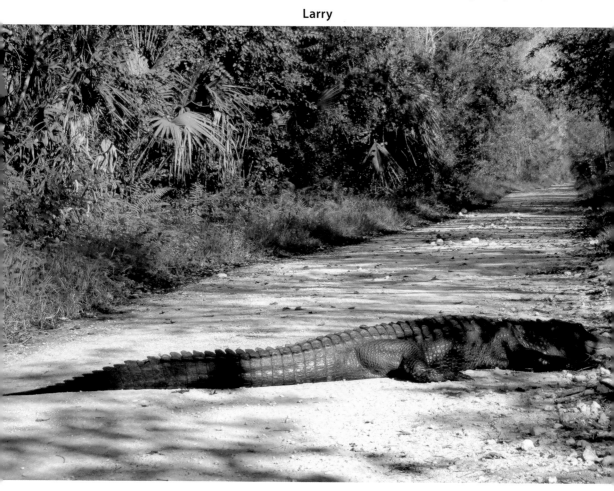

gator will head for the water."

The men returned to the truck, and as predicted the alligator—with much hissing—slid into the swamp as they went by. Poor Larry, now he'd have to start his whole warming routine again. I took advantage of the open road and continued deeper into the park.

I spent the next few hours driving in short increments, exploring ahead on foot, and repeating. Birds were a bit tough to find here, but butterflies made up for it. Species I found included a cloudless sulphur butterfly, a white peacock butterfly, a zebra longwing butterfly, and a viceroy butterfly.

Throughout my travels, I have found dozens of animal mimics, and the evolution of those species has always fascinated me. Some are harmless creatures that mimic deadly creatures; others are camouflage masters that mimic their surroundings.

With that in mind, the viceroy butterfly was a special find for me, as it mimics the monarch butterfly. Why? Monarchs taste bad and are mildly poisonous. Viceroys taste good—like a butterfly should!

Cloudless Sulphur Butterfly

Zebra Longwing Butterfly

Above: White Peacock Butterfly
Below: Viceroy Butterfly

Eventually potholes threatened to swallow my little rental car, and I had to turn around. But I didn't leave. As I was driving in, I had noticed several old logging tram roads (loggers had clear-cut much of the park in the 1940s, but since then the land has largely recovered), which were gated but open for hiking. I selected one at random and started walking.

The road went perfectly straight for as far as I could see. But it was really more of a trail than a road, as the vegetation had closed in and the trees had arched over the top, giving it a covered bridge feel. Adding to the bridge feel were swamps on each side. This wasn't a dark place, however, as the sun sneaked through breaks in the trees to light the way.

I hiked for about an hour, stopping frequently to photograph the wildlife and scenery. By now most of the wildlife species I came across were repeats of what I had seen earlier.

When a splash startled me, I peered between a thin barrier of branches and spotted a juvenile little green heron, fishing. After several dives into the water, the bird flew toward me and perched on a low branch. Only a few feet away, she was seemingly unaware of my presence. I snapped some photos and just enjoyed the company.

Fakahatchee Strand Preserve State Park had turned out to be one of my best finds ever. Life is like that sometimes. Without knowledge of what's ahead, you just pick a destination and go for it. You may fail and hit a dead end, or you may succeed and find something incredible. Either way, participating in your own adventure—be it the pursuit of a sight, an experience, or an accomplishment—is far more fulfilling than sitting at home (or in a hotel room) watching someone else's adventure on a reality TV show.

I was just about to turn around and return to Everglades City for a final time when I remembered that I owed my wife a phone call. I hadn't seen another human since the park rangers, and certainly the nearest cell phone tower was miles away. Could I get cell service out here? I'm not the kind of person who carries a smartphone and needs to be connected at all times. In fact, my basic cell phone is turned off way more often than it's turned on. I pushed the power button and looked at the screen: one bar. And if I turned just so, the second bar flickered. That was all I needed.

"Deb! I so wish you were here. You'll never guess where I am now. . . ."

Little Green Heron

— 4 —

Bat an Eyelash and Monkey Around in Costa Rica

Deb and I tend to go on our major trips in clumps. After enduring six years without a vacation, we visited all seven continents on an epic three-and-a-half-year-long adventure that ended in 2004. Then, after Deb took time off to run for the Montana Legislature and I took time off to write and promote my first book, we visited Puerto Rico in 2006 and the Arctic National Wildlife Refuge in 2008.

From that point on, we both got involved in various projects. She worked to get a weaving kits business off the ground and write her first book; I turned my first book into a live stage show, *Around the World in 90 Minutes*, and performed it at colleges across the country (something I still do).

When 2014 arrived, we both agreed an overseas trip was a must. The fact that our thirtieth wedding anniversary was coming up on September 15 gave us an additional incentive to pack our bags—as if we needed an incentive. Practically since our first international adventure, a trip to Belize in 2001, Costa Rica had been on our list of must-visit countries.

I purchased a few Costa Rica travel books, and to give us an option, I purchased one about Panama as well. Before long, Deb was scouring the books for possibilities and visiting websites for more information. Soon she found several places that looked promising.

One was the Playa Nicuesa Rainforest Lodge, in southwestern Costa Rica, on the eastern side of a gulf, opposite the Osa Peninsula. According to

the website, the lodge maintained a 165-acre private preserve in one of the most biologically diverse places on earth. And, with no roads in the area, we could only get there by boat.

That all sounded wonderful. Then I noticed the lodge offered a package called *Frogs, Bats, and Snakes.* They even mentioned eyelash vipers. I was sold! My previous travel experiences told me that lodges in tropical places frequently try to hide the fact they have venomous snakes in the area. Here they were actually embracing them—figuratively, of course.

During our earlier travels, Deb and I were frequently on the move. For this trip, we would stay the entire time in one place. I liked that idea, as immersing ourselves in a single area would allow us to observe a greater percentage of the plants and animals that lived there. On the other hand, since we wouldn't be backpacking with a headhunting tribe, shooting rapids in the Arctic, or canoeing past herds of hippos, we probably wouldn't have any adrenalin-pumping adventures either. But that was okay. It was our anniversary trip after all.

We arrived in San José, Costa Rica, on December 13. As we had experienced on previous trips to Belize and Peru, a mass of people holding signs and offering rides met us at the airport exit door. I flashed back to the aggressive hustlers we encountered at the Jorge Chávez International Airport in Lima and immediately went on the defensive. The hotel where we were staying had told us they'd have someone waiting for us. When we didn't see a sign with our name on it, we had to improvise. Soon, friendly people were directing us where to go to meet the hotel shuttle, and no one tried to grab our bags or herd us into an unmarked cab. I liked Costa Rica already.

The next morning we were up early to catch a Sansa Airlines flight to Golfito. Sansa is one of Costa Rica's two domestic airlines, and they have their own terminal and security team. That security team turned out to be a solitary woman, who took a cursory look at some items in Deb's backpack and ran a metal detection wand over her. As for me: she opened my pack, zipped it right back up, and didn't even bother to wand me. What was the worst we could do—hijack the twelve-seat airplane and demand the pilots take us to Panama?

An hour later, we landed at the funky little Golfito Airport, which is a single landing strip cut into the rainforest, with a reservation counter, bench, and vending machine under a protective canopy. A lodge employee met us at

the airport, and soon we were on a boat, heading up the gulf (called *Golfo Dulce*) toward the Playa Nicuesa Rainforest Lodge.

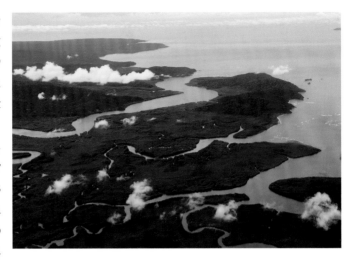

Upon our arrival, the lodge manager handed us fruity drinks and walked us through a brief orientation. To the best of my memory, the orientation speech went something like this: "Welcome! Yadda . . . yadda . . . yadda. There is an eyelash viper directly behind the main lodge building. Yadda . . . yadda . . . yadda . . ."

If I were to list all the animals I hoped to see while in Costa Rica, an eyelash viper would be among my top five, along with a howler monkey, a scarlet macaw, a toucan, and a bushmaster. As soon as the manager completed our orientation, I asked him to point me to the viper.

Why was I so eager to see an eyelash viper? Of all the snakes one could encounter anywhere in the world, eyelash vipers may be the coolest. First, they come in a variety of colors, from green to brown to pink to yellow to white—and all those colors can come from the same litter. Second, they have

Eyelash Viper

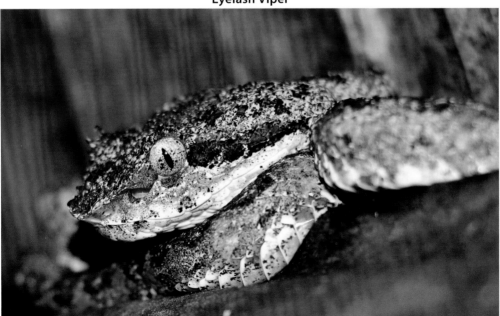

rough scales rather than smooth scales—including a unique set of scales that protrude above each eye to give the appearance of eyelashes. And yes, they are venomous—though their bite is seldom fatal to humans.

This particular viper was in the undergrowth of a cluster of palms. She was mostly green, and without someone to point her out, I would have never seen her. I photographed the eyelash viper from several angles, then turned to my wife and said, "Okay, Hon, we can go home now!"

We moved into our cabin. El Dorado was definitely not a typical cabin. It had newly varnished hardwood floors, and everything was open-air, including the shower, bathroom, bedroom, and porch. Privacy wouldn't be a problem, however, as the bathroom and shower had five-foot-high walls. Dense vegetation and the cabin's isolated location took care of the rest. Despite being in a rainforest, biting flies and mosquitos wouldn't be a concern for us either. And even if we had a night where the flying pests were unusually pesky, our bed had mosquito netting around it to protect us. The one thing that surprised me was that, apparently, we didn't need to worry about marauding monkeys. I'd keep my camera gear out of sight, just the same.

With 165 acres of land and miles of hiking trails, Deb and I would never need to leave the lodge's property on foot. Each day we'd explore one or more trails. On our first full day, we chose the trail that began closest to our cabin. Except in a few places, the trail was well marked and moderately easy to hike.

We walked slowly, taking in our surroundings. Many years before Playa Nicuesa became an eco-lodge, the land here had been part of a cocoa plantation. Fortunately, many of the large strangler figs and almond and ceiba trees had been saved. Also, just being located in a rainforest meant that many of the plants grew back quickly. The average person would never know they were in a secondary forest.

Among the first creatures we saw were a small lizard and a hecale longwing butterfly. One of my goals on this trip was to photograph as many

Hecale Longwing Butterfly

butterfly species as I could, so the orange and black beauty was the first in my collection.

A squeaky, rhythmic birdcall interrupted my butterfly photography. As a writer, I know it's my duty to add excitement here by spelling out the sound of the call—with lots of dashes and exclamation points. But I'm sorry. It just can't be done. I even checked to see how other authors spelled out the call, but when I pronounced what they wrote, it wasn't even close to the sound a chestnut-mandibled toucan makes.

At the time, of course, I had no idea what I was hearing, other than something that was most likely a bird. Deb and I ran up the trail and tried to locate the source of the call. The call would repeat for a minute or so and then stop. Then, just when we thought the bird had moved on, the calling started again.

After several minutes, I spotted it. "Deb, it's a toucan!"

"Where?"

"See that big tree about thirty feet back? Now follow that long branch to the right. The toucan is halfway up, partially blocked by a clump of leaves."

"Oh my God! There he is. I can't believe you found him."

Chestnut-Mandibled Toucan

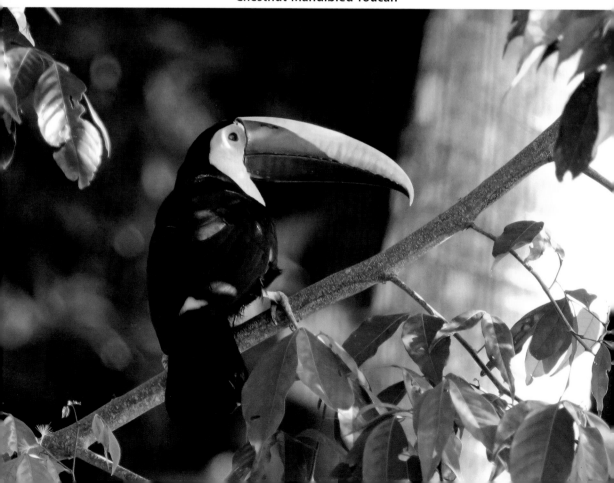

Reaching twenty-two inches in length, chestnut-mandibled toucans are Costa Rica's largest toucans. When seen in person, their yellow and maroon bills look too large for their bodies. When they call, they jerk their heads back, as if the force of the sound is too great for their necks to support. And when one hears their high-pitched squeaky calls for the first time, the image of a much smaller bird comes to mind. So while toucans are gorgeous, they are out of proportion in many ways. As for their diet, they eat fruit, eggs, large insects, and small animals— and I suppose, if given the chance, they'd even eat Froot Loops.

Eventually the toucan flew to another tree, and we continued our hike. For the next hour or so we saw mostly small animals, including a four-inch-long white millipede and a thumb-sized black beetle, which had a sharp, angular build that made it look like an invader from another planet. On the eye-candy side, we spent several minutes observing a squirrel cuckoo, which had fluffy feathers and a long tail. Normally I wouldn't think of a brown bird as attractive, but this one was absolutely beautiful.

Our route looped in a wide semicircle. We were about fifteen minutes from the lodge when I heard rustling high in the trees. "Deb," I excitedly whispered, "monkeys!"

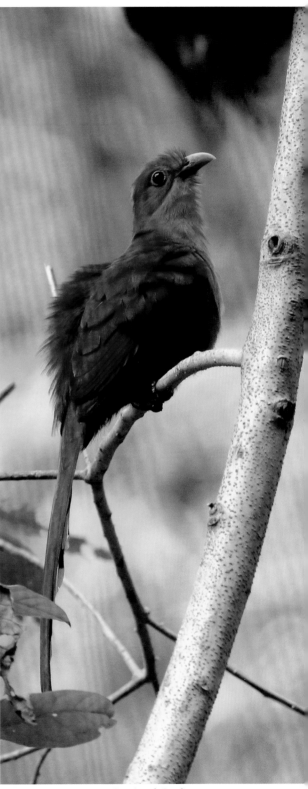

Squirrel Cuckoo

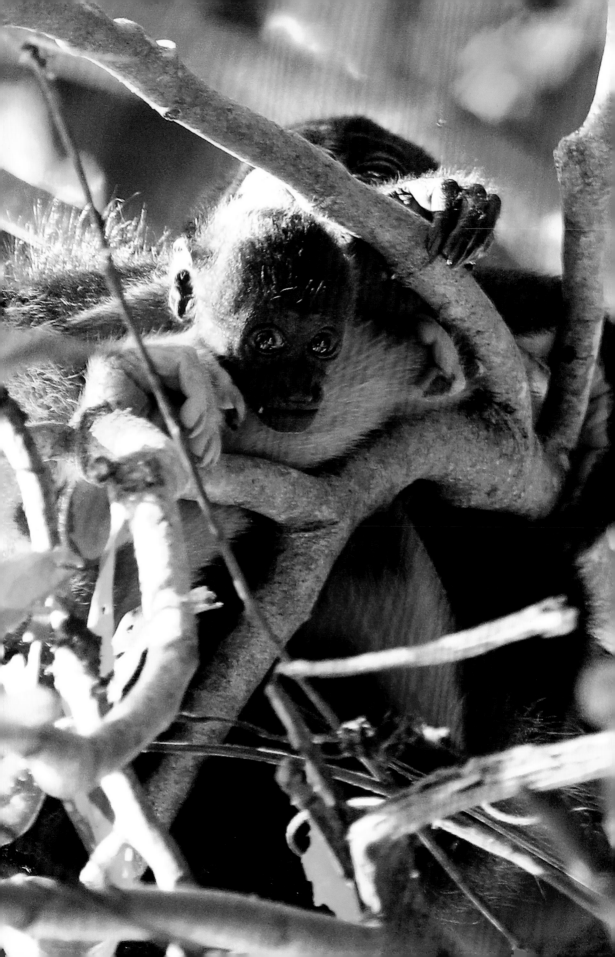

After much pointing and repositioning ourselves, Deb whispered back, "You have the find of the day."

What we were looking at was a troop of seven to ten howler monkeys. Coming up with an exact number was difficult, as some were shifting positions and much higher in the trees than others.

"Look it! Look it! There's a baby," said Deb.

"Oh! He's so cute!" And in this instance, I wasn't just choosing a random pronoun—*he* was definitely all male.

As we watched, I realized that the baby howler monkey was just like most boys—constantly moving. The only difference was that he did it at fifty feet in the air. One moment he'd be clinging to his mother's chest; the next he'd be on her back; and the next he'd be taking a few independent steps on a tree branch. That he was able to do that day after day without falling—or without his mother finally having had enough and pitching him in frustration—was simply amazing.

Even though the howler monkeys knew we were beneath them, they didn't seem to care. A few times they let loose with streams of urine, but we couldn't be sure whether they were deliberately trying to get us wet or just had to go. Either way, as long as we stayed alert, we could see the showers coming and dodge them just in time.

Howler monkeys are one of the largest monkeys in Central America, with adult males weighing up to twenty-two pounds. Their diet consists mostly of fruit, nuts, leaves, and flowers.

I can't imagine anyone who appreciates nature not being excited about spending time with a troop of howler monkeys. My wife and I, however, had an extra reason to be excited. We had been to Belize once, and the Amazon Rainforest twice, and this was the first time we had been able to observe New World monkeys that didn't immediately flee in fear.

We stayed with the howler monkeys for about an hour. And although we would hear their howls—actually *roars* is more accurate—in the distance throughout our stay, we'd never see more than a flash of them in the trees again.

Digital photography has made some incredible advances since Deb and I began traveling internationally. Virtually every trip became an excuse for me to buy a new camera (and a subsequent excuse for Deb to playfully give me a hard time about making an "unnecessary" purchase). Several months before we left for Costa Rica, I meekly announced to my wife that I had

purchased a new Canon EOS Rebel SL1 digital SLR camera and a mint, but used, Canon EF 300mm L-series telephoto lens and a Canon EF 1.4x extender. Those who know photography may wonder why I don't use one of Canon's high-end professional cameras, like the EOS 5D Mark III. Other than not wanting a camera that would inhibit my adventures (because the cost of breaking it would make me too cautious), the main reason is weight. For instance, in Costa Rica, Sansa Airlines limits luggage to thirty pounds per person, and an EOS Rebel SL1 is less than half the weight of an EOS 5D Mark III. Sure, I'd lose some speed and features, but the EOS Rebel SL1 is still a high quality camera.

Howler Monkey

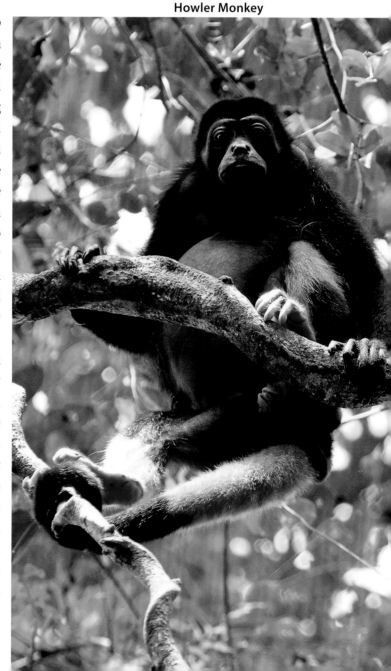

I bring this up now, because even though Deb gave me her patented wicked little smile for dropping more than two grand on updated camera equipment, when we would review the photos each evening on my tablet (which I also purchased specifically for this trip), she'd often comment, "I'm so glad you bought that new lens and camera!"

After today's toucan and howler monkey encounters, I was glad as well. For the type of photography I do, there's no time to set up a tripod, as the animal in my sights could either be on the move or gone in a flash. Additionally, the rainforest complicates

the task, as light is usually in short supply. My latest photographic purchases made several shots possible that would have turned out either muddy or blurry with my previous equipment.

Part of the lodge experience was social time each evening. For much of our stay Paul Gagnon and Yvonne La-Garde from New Hampshire were the only other guests at the lodge. The couple was a bit older than us, but we instantly bonded. Paul looked a lot like Jonathan Goldsmith, the actor who plays "The Most Interesting Man in the World" in the Dos Equis beer commercials,

Veronica (a lodge guide) and Deb

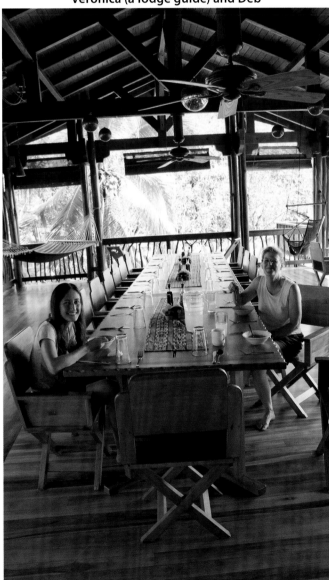

and Yvonne was a dead ringer for Chrissy Hynde of the rock band The Pretenders. People seldom agree with my opinion of who looks like whom, but later in our stay, I brought up a photo of Chrissy Hynde on my tablet and everyone agreed.

That evening Deb and I sat at the bar and enthusiastically told Paul, Yvonne, and any staff members within earshot about our first day exploring the rainforest.

Although this chapter is about our Costa Rican wildlife adventures and not an advertisement for the Playa Nicuesa Rainforest Lodge, I would be remiss if I didn't mention the food. The lodge kitchen

staff served all meals family style, on a long table, in a large open-air dining room.

Breakfasts typically included coffee and tea with a choice of cereal, fruit, bread, and eggs cooked to order. Lunches generally included soup, salad, and a sandwich. Dinners were usually fancier, with a fish or chicken dish, rice, and dessert. That all sounds fairly basic, but what made the meals special were the local ingredients and local recipes. Every meal included some sort of fresh fruit juice, and the main dishes were always based on ingredients that could be picked, caught, or purchased within the region. Although I can't honestly say I liked everything put before me, overall the food was delicious, and the variety made each meal an adventure.

Even though the sun had set, our day was far from over. Each day of our stay followed the same basic schedule: Wake up at first light to some sort of animal call (usually a bird called a gray-necked wood-rail). Do some minor exploring. Eat a hearty breakfast. Go on a major daytime adventure. Eat a late lunch. Hang out on the cabin porch during the afternoon rainstorm (while reviewing and backing up the day's photos). Enjoy social hour and dinner. Head out on a night hike.

Our Frogs, Bats, and Snakes package included guided evening and night hikes. Deb and I learned a long time ago that rainforest hikes after dark frequently produce higher animal counts than similar hikes during the day. We have also learned the importance of local guides, as their eyes are already attuned to the surroundings, and they have a better idea of where the indigenous animals may be hiding.

Jose guided our first night hike. He was a slight yet athletic man in his twenties. He spoke efficient English, although it obviously wasn't his first language. Rapid-fire conversations weren't his style, as he'd frequently pause to think before speaking.

Prior to our hike, I had mentioned to Jose that my goals for the evening were to find two venomous snakes: a bushmaster and a fer-de-lance. He responded by saying he wasn't aware of anyone ever finding a bushmaster in the area, but a fer-de-lance was a distinct possibility. "Okay," I said. "A fer-de-lance it is!"

With flashlights in hand and rubber boots on our feet (to protect against snakebites), we started down a trail that led from the lodge. Jose was in front; I was in the middle; and Deb brought up the rear. A few minutes into our hike, I started thinking, "He's walking way too fast." I slowed my pace,

forcing Jose to slow his when he realized we were lagging behind.

Soon Deb and I started finding little creatures of the night, including lizards, katydids, and colorful moths. Although animal counts aren't a competitive sport, I was surprised how many more animals the two of us were finding than our guide was. Deb whispered to me, "I don't think Jose is used to hiking with people who are into finding the little things."

My best find on the hike was a brown blunt-headed vine snake. Such a long name for such a tiny snake! Perhaps sixteen inches in length, she was skinnier than a pencil and her relatively large, blunt head was true to her name. I tried photographing the delicate creature on the small fern she was occupying, but I couldn't get my camera to focus as accurately as necessary in the dark. The best chance for a crisp photo would be to give Deb my camera, capture the snake, and have her photograph it in my hand.

Other than eyes familiar with the surroundings, the other advantage of local guides is that they usually know the basic natural history of the

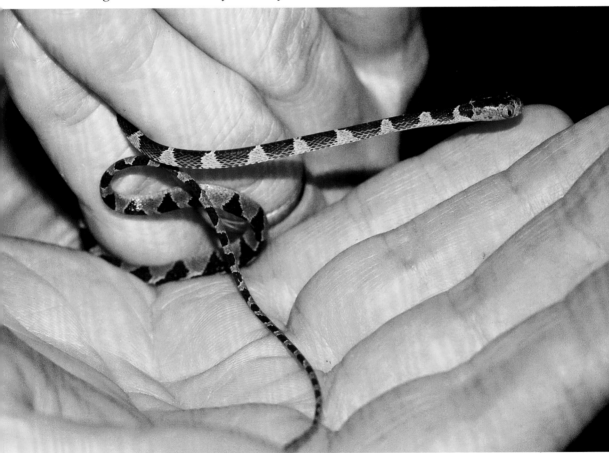

Brown Blunt-Headed Vine Snake
(Photo by Deb Essen)

indigenous wildlife. Seeking their advice before touching any animal is always a good idea.

"That is a brown blunt-headed vine snake," said Jose.

"Is it venomous?" I asked.

"I don't think so. It might be rear-fanged."

I gently captured the snake, and Deb took some photographs. Although the snake was incredibly docile, my later research uncovered that brown blunt-headed vine snakes are indeed rear-fanged venomous. Their venom, however, is just potent enough to immobilize the small lizards and frogs they eat. A bite to a human would likely be harmless.

After an hour of spotting only a fraction of the animals Deb and I had spotted, Jose rallied to make some finds of his own. His best were a rain frog and several varieties of walking stick. I was also glad to have him in the lead, as my sense of direction was totally confused, and I didn't have to worry about getting lost in the dark.

Then, just as our hike looped back to the lodge, Jose made my night.

"Fer-de-lance," he whispered.

Fer-de-lance

I followed Jose's flashlight beam and located the snake. "Wow! I would've never seen him."

The name "fer-de-lance" could mean any of several related snakes. The most common are the *Bothrops atrox* and *Bothrops asper*. I had seen the first species in the Amazon Rainforest, and now I was feasting my eyes on the second. *Bothrops aspers* are the larger of the two (reaching eight feet in length) and are generally considered to be more dangerous. Collectively, the two species of fer-de-lance account for more snakebite deaths than any other snake in the New World.

I know finding such a snake isn't exciting for everyone, but people have differing interests. (For the life of me, I can't understand why anyone would find a reality TV show exciting.) Here's what I found exciting about the fer-de-lance: not only was I looking at one of the most feared snakes in the Americas, but I was also looking at a snake with incredible camouflage and striking beauty—especially with the raindrops beading up on his skin.

The camouflage, by the way, is one of the reasons fer-de-lances are so dangerous. People walking through the forest often don't see the snake and step on (or too close) to it. The snake has no way of saying "get away from me" other than biting.

We wrapped up our night hike with a swing past the beach. There I found a spiny yellow orb weaver spider, and Jose pointed out a six-inch-long smoky jungle frog (one of the world's largest species of frog).

Above: Orb Weaver Spider
Below: Smoky Jungle Frog

What a night! We ambled back to our cabin to prepare for another day.

One consistent element of all of Deb's and my travels is that I get up before she does to enjoy a solo mini-adventure. On this morning, the sun

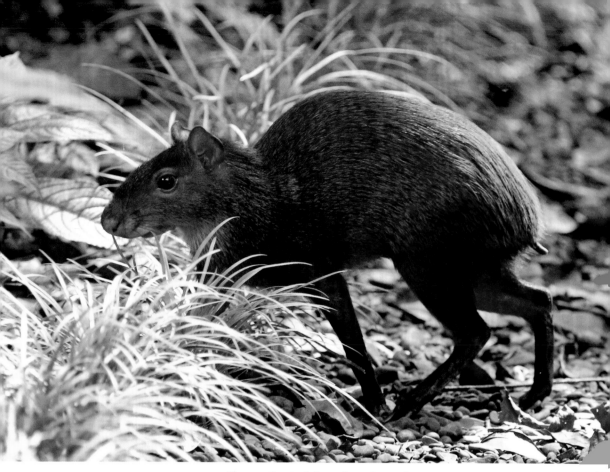

Above: Central American Agouti
Below: Great Curassow (female)

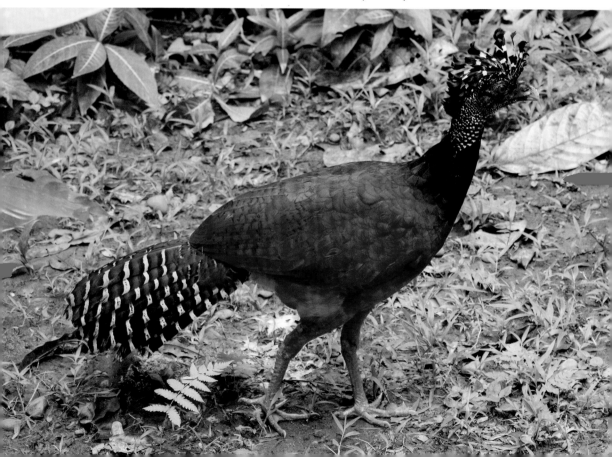

was glistening off the previous night's raindrops, and the air smelled fresh yet slightly earthy. I left Deb curled up in bed and quietly worked my way down the path leading from the cabin. The great thing about our location was that we never had to travel far to see something new.

Several times since our arrival, I had heard heavy rustling on the rainforest floor. That sound, of course, could be anything, and my expectations of actually seeing the creature responsible for it were low. When I heard the rustling this time, I froze. Moments later a large rodent appeared at the edge of the trees, thirty feet in front of me.

"Capybara?" I wondered. "No. The rodent is big, but not that big."

I continued watching and photographing. Before long, I glimpsed another one off to my side. The animals either didn't realize I was standing there or didn't see me as a threat. After both melted back into the underbrush, I consulted one of the wildlife books at the lodge. I had been watching Central American agoutis—rodents that can weigh up to nine pounds. The wildlife book claimed that agoutis resembled guinea pigs, but I saw them differently. To me they were more like small vegan dogs with buckteeth.

Other animals joining me on my morning walk included male and female great curassows. Standing three feet tall, these shy ground birds made me think of the bustards I had seen in Australia. And like bustards, although they can fly, the ground is where people see them most often. To my eyes, the prehistoric-looking great curassows contradicted the common notion that the males of a bird species are more colorful than the females. With great curassows,

Great Curassow (male)

the females are a handsome golden brown and the males are mostly black.

Once Deb woke up, we had breakfast and headed out on another hike. This time we took a trail that would loop through the rainforest and drop us on the beach. Not every hike is eventful, and this time the majority of our route was mostly trees and ferns with the perpetual promise of a great wildlife adventure around the next curve. Still, just being in a rainforest beats sitting on a couch any day.

Eventually the trail began dropping to the beach, and we could hear the waves in the distance. "Something's up in that tree," whispered Deb.

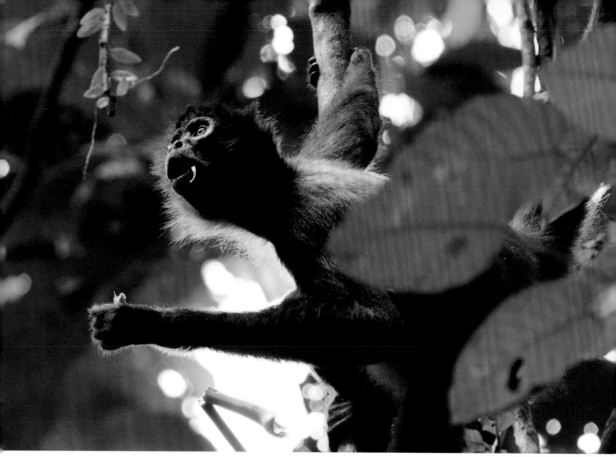

Spider Monkey

We then began our familiar ritual of pointing, whispering, and repositioning. Before long, we were looking at a troop of five spider monkeys, working their way from tree to tree.

Every animal encounter has the potential to become a learning experience. And with monkeys, the odds of learning something are especially high. In this instance, I learned that monkeys do indeed fall. When one attempted a long jump to another tree, his landing branch broke, and he plummeted toward the rainforest floor with a terrified scream. Fortunately, just like Spider-Man, he reached out and grabbed something—at the last possible moment—to break his fall and live another day.

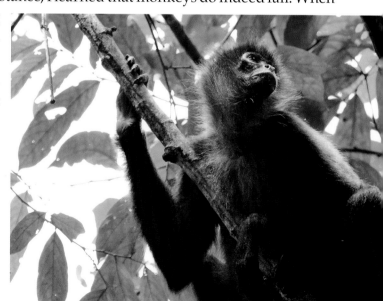

There are seven recognized species of spider monkey and numerous subspecies. All are threatened due to habitat loss and hunting. Yes, people in some countries still eat them. The species here were Central American spider monkeys (also called *Geoffrey's spider monkeys*), and the International Union for Conservation of Nature (IUCN) lists them as "endangered." Two unusual physical characteristics of spider monkeys are that they have four long fingers and only a vestigial thumb (a full-sized thumb could interfere with swinging from branch to branch), and the females have a large pendulous clitoris that is more visible than the males' penis, making sexual identification confusing—at least for humans. Over all, spider monkeys are large—roughly the same size as howler monkeys.

Unlike the howler monkeys we saw the previous day, these spider

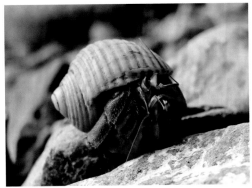

monkeys moved off quickly, so we continued down to the beach. "Watch where you step!" yelled Deb. "There are hermit crabs everywhere."

She wasn't exaggerating. This was obviously the time of day to head for the water, as countless crabs—from marble to ping pong ball size—were all marching in the same direction.

Hermit Crab

As for Deb and me, we had more on our Costa Rica menu than just rainforest hikes. The two of us plopped down on the beach—which was more rocks than sand—and enjoyed some relaxation time. That for us, however, meant regular but welcome interruptions whenever a brightly colored crab or butterfly entered our field of view. And even without some sort of animal activity, tall overhanging palms, gently lapping waves, and puffy white clouds kept us in perpetual contentment.

Unfortunately, as much as our pre-trip fantasies included lying on

Swallowtail Butterfly

the beach for hours on end, we couldn't escape the reality that we were fair-skinned people from the north. A sunburn this early in our trip would be especially unpleasant. We returned to our cabin before we became crispy critters.

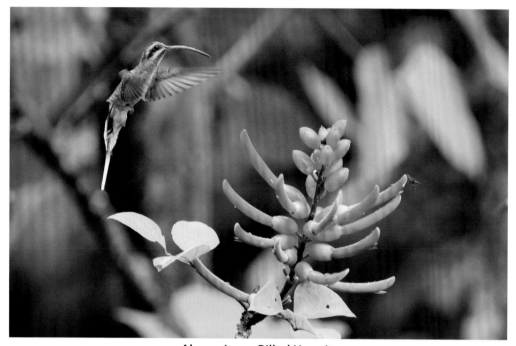

Above: Long-Billed Hermit
Below: Postman Butterfly

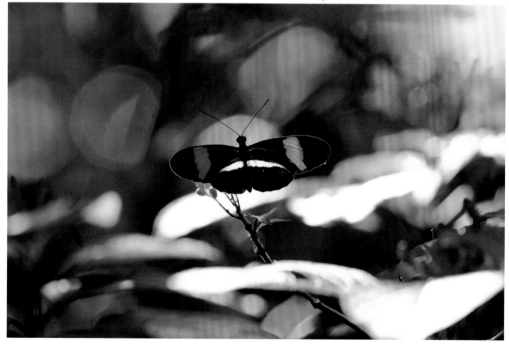

Hanging out at our cabin was never boring, because it was a great location for animal sightings. Of the eight cabins at Playa Nicuesa Rainforest Lodge, we had the best one by far. With a wall of rainforest foliage, roughly ten feet out from the cabin in all directions, we'd often sit on our open porch and wait for the wildlife to come to us. Or, if we wanted more action, we'd simply circle the building. During our stay, we'd see monkeys, katydids, rodents, lizards, snakes, birds, crabs, millipedes, and bats—all from either the cabin porch or the immediate grounds.

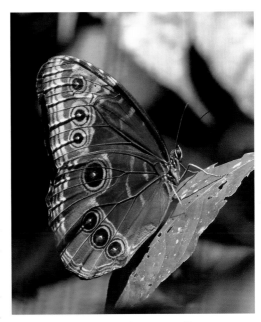

Blue Morpho Butterfly

And remember, our cabin was completely open—essentially a platform with a roof and storm shutters (which we never closed).

Only once did the cabin's open style make us nervous. We were sitting on our porch when Deb noticed a long column of army ants approaching our steps. Before long, they climbed onto the first step, then the second, and then the third! By the time they reached the second step from the top my mind was racing, "How do you stop an army of army ants in the jungle? It's not as if we can take a can of Raid and wipe out the entire colony. And if they move in, how long will they stay?"

Then, as if someone had flipped a switch, the lead ant changed direction and headed back down the steps. The rest of the column followed. Within minutes, only two or three confused ants remained in sight. "Whew!"

Reptiles dominated the rest of our day. Deb was sitting on our steps, when she noticed a male anole lizard on a nearby leaf. We knew he was a male, because every so often he would flash a large flap of skin under his neck, called a *dewlap*. The purpose of a dewlap is to attract females and warn other males that they are in occupied territory. We didn't see any other anole lizards around, but then we mere humans can be woefully unobservant. Our resident anole was convinced that hundreds of his kind surrounded us.

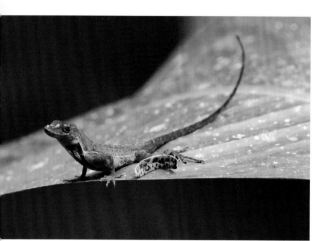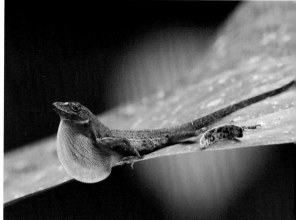

Anole Lizard

Eventually Deb grabbed a book and walked to the gulf, one hundred yards away. There she could read in a well-shaded hammock, next to a gurgling freshwater stream that paralleled the ocean, on the opposite side of the beach. While she did that, I stayed at the cabin and loaded photo files onto my tablet.

An hour or so later, Deb came running up the path to the cabin. "Grab your camera! There's a huge Jesus Christ lizard by the water!"

I had read about Jesus Christ lizards in books, and had always wanted to see one in person, but had no idea they were in this part of Costa Rica. I hurried behind Deb and was soon feasting my eyes on the exotic-looking lizard. Technically the common name for the lizard is a striped basilisk, but nearly everyone calls them Jesus Christ lizards, because they can run across rivers and small ponds without sinking. The lizard Deb had found was a full-grown adult male, perhaps 20 inches from tail to snout.

"What a great find, Deb! How did you spot him?"

"I was reaching down from my hammock, when I heard all sorts of rustling in the leaf litter. I looked up, and there he was."

Later I'd have the opportunity to watch several smaller Jesus Christ lizards do their water run. They cracked me up each time. Not only were they lightning fast, but they also ran on their hind legs. I tried to photograph the lizards in mid-run, but I wasn't quick enough to scare them into a dash and aim my camera at the same time. After a couple of attempts that only showed circles in the water—where the lizards had stepped a fraction of a second earlier—I gave up. Besides, even though frightening the lizards was harmless to the animal, the act felt contradictory to both my wildlife watching and photographer's codes of ethics.

Jesus Christ Lizard

Ready, set . . .

Run!

After dark, Deb and I embarked on another night hike. Since we now had a comfortable knowledge of the immediate area, and obviously didn't need a guide to point out wildlife, we decided to do this and all future hikes on our own. The one thing that made this night different from all others during our stay was that instead of a heavy afternoon rainstorm we only had a light afternoon shower. That dramatically changed our luck, as the creatures of the night weren't in nearly the concentrations they had been the night before. We saw a few katydids and a rain frog, and that was about it.

We cut our hike short, stopped at the lodge bar to buy two "take-home" glasses of wine, and headed down the path to our cabin. We were only a few feet from the cabin's steps when Deb shouted, "Snake!"

Having lived with me for thirty years meant that when Deb shouted "snake" she didn't have the inflection of fear in her voice that so many other people would have. And in this case, her voice even had a trace of giddiness in it. I set down my wine and turned back to where she was standing.

"Oh my God! You found another eyelash viper."

Coiled on a large chest-high leaf, this white eyelash viper was smaller than the green one we had seen previously. At most, he was eight inches long.

"I don't know how you spotted him," I continued. "I walked right past him."

"I just happened to catch him in the beam of my flashlight."

"I wonder if he just crawled up there tonight, or if he's been there the entire time?"

Above: Katydids and a Rain Frog
Below: Fred

Careful not to startle the little viper into striking or fleeing, I shot a series of photos. Unfortunately, the leaf the snake had chosen made this difficult, as it was a bit too high to shoot down upon, and coming in from the opposite side was impossible without jiggling the stem or risking exposure to an unseen brother or sister. Smart snake.

"Let's name him 'Fred,'" said Deb.

The next morning Deb and I broke from our hiking routine and boarded a small, canopied aluminum boat, with guides Jose and Eric, and new friends Paul and Yvonne. Today was mangrove day, as we would head north along the coast and up a river to a mangrove forest. The mangrove tour was part of our Frogs, Bats, and Snakes package, as well as one of the lodge's stand-alone trips. That's how we ended up getting paired with Paul and Yvonne, who had purchased the mangrove tour à la carte.

By six thirty, we were motoring along with kayaks towed behind us. The morning was stunning, as the sun shimmered off the calm gulf water and a distant wall of still-damp rainforest. No doubt, we were all thinking some version of "This is paradise!"

If there is one thing I don't fit into well, however, it's cookie-cutter tours. We stopped briefly to watch some toucans in the trees along the beach and made additional stops to watch some bottlenose dolphins and an eagle ray,

Bottlenose Dolphin

but a few of those stops felt rushed—especially the one for the dolphins. For me, it's the journey that's important, not the speed or the distance. I vowed to myself to start speaking up.

Our outgoing motorboat ride concluded on a deep, lazy river that was roughly forty yards across. Rainforest abutted the water on both sides. We each climbed into a kayak and started paddling. The plan was to explore the river and mangroves via kayaks, while our boat driver motored several miles downriver and waited for us there.

The riverbanks were teeming with wildlife, but to see the animals you had to look in the right place at the right time. Two animals I completely missed were an anteater and an olive-throated parakeet. Both were in trees.

For the anteater, Deb said, "See that tall tree with the broken branch? Now look two trees to the right of that and follow the branch going off to the left. It's right there in the opening." *Arrggh!*

For the olive-throated parakeet, I was trying to spot a medium-sized green bird against a near-solid wall of trees the same color. After a moment of frustration, I handed my camera

Olive-Throated Parakeet
(Photo by Deb Essen)

to Deb. "Here. You photograph it, and I'll look at it later." Considering how far away the bird was, she captured an amazingly sharp image.

Other sightings on the river included two six-foot-long Central American tree boas and a two-inch-wide spotted mangrove crab. The snakes, unfortunately, were in thorny bushes overhanging the river. Since they were a few hundred feet apart, I maneuvered my kayak under the first one, shot multiple photos, and then repeated the process with the second one. In both cases, no matter what angle I aimed from, I couldn't find either snake's head.

As for the mangrove tree crab—with its black carapace, white spots, and bright orange claws—it was one of the most dazzling crabs I'd ever seen. Photographing the crab was difficult, however, as the slow-moving

Central American Tree Boa

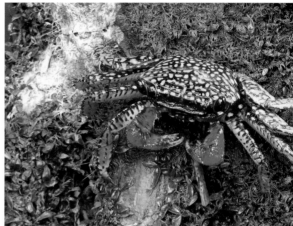

Mangrove Tree Crab

water meant that I had to paddle a bit upriver, drift past the crab while shooting, and repeat. After several tries, I looked up and noticed that our guides were now far downriver. Deb had stayed next to me in her kayak, and the two of us paddled hard to catch up.

Shortly after pulling even with our guides, another sight caught our attention, and we fell behind again. Deb and I have traveled all over the world and worked with multiple guides, both good and bad. In my book, the best guides never leave their clients in their wake.

I had a flashback to working with Richard, our guide in the Arctic National Wildlife Refuge. We were out on the tundra when a grizzly bear strolled by. My wife and I never carry weapons, but everyone, including our guide, carried bear spray. We also had the advantage of being in a group. After a moment or two of watching the bear, Richard seemed to forget we were there and took off over the next hill. Although everything turned out fine, I was angry with him for being more concerned about maintaining his hiking pace than the well-being of his clients.

Now, watching our Costa Rican guides lengthen the distance between us, that anger came back. In this instance, it wasn't danger. It was lack of consideration and knowing that Eric was a trainee on his first guiding outing. If Jose didn't lead him in the right direction, future clients would likely encounter the same problem.

I dug my paddle deep into the water, repeating each stroke as quickly as I could. As soon as I was within earshot, I yelled, "Jose! Eric! Here's a guiding lesson for you: *Slowww . . . dowwwn!* You guys may be familiar with Costa Rica, but this is all new to us. At the speed you're going, we're going to miss half of what we came here to see."

Then, after a pause, I added, "You are really starting to piss me off!"

Whoa! Where did that come from? I'm normally an easygoing guy, and after a few minutes of reflection, I started feeling guilty about my outburst.

Ten minutes later, Jose led us up a narrow channel of what could best be described as *spooky water*. This was the mangrove forest. Although various

species of trees and shrubs surrounded us, they all sat on elevated, spider-like roots. Some of the roots reached more than eight feet into the air before joining up with a tree trunk. With a little imagination, one could visualize the trees walking from place to place under a full moon. With a little science, one could understand that these aerial roots have multiple functions—from helping the tree withstand tides and storms to allowing the exchange of air in the waterlogged, oxygen-poor soils.

Taking advantage of the intimacy provided by the mangrove forest, I paddled beside Deb and whispered, "Was I out of line, saying what I did to Jose and Eric?"

"No. I was thinking the same thing you were. They needed to be told. But . . . I would have said it with a nicer tone of voice."

"Yeah. You're right. I'll apologize to them."

At the next bend in the river, I drifted up to our two guides, apologized for my outburst, and more gently explained to them my feelings on the subject of pace.

Paul helped me out later by asking Jose, "Do you need to get back to the lodge by a specific time?"

"My only responsibility for the day is you people," he replied.

From that point on the tension eased and our schedule became more of a cooperative undertaking. Which was critical. Because if we had followed the standard tour schedule, we would have never experienced the adventures ahead.

Terns

Upon meeting up with the motorboat, Jose asked us if we were ready to return to the lodge.

"If no one is in a hurry, I'd love to paddle up the river and explore some more," said Paul.

"That would be fine with me," I said. "But what I'd really like to do is head back along the coast to see if we can find the dolphins again."

"Dolphins sound like a great idea," said Yvonne.

Deb added, "I'm getting kind of crispy here in my kayak. It's that fair Norwegian skin. It can only take so much sun. I vote for the dolphins too."

I felt a wee bit bad for instigating a plan that overrode Paul's idea, but Paul was an affable person and readily agreed that trying to find the dolphins would be fun.

We motored downriver, stopping frequently for bird sightings. The late morning sun made the day sparkle, and even drably colored shorebirds, such as whimbrels and willets, popped out against the scenery. But most spectacular were the brown pelicans. Or, as Deb would say, "most comical."

Deb's reasoning was because brown pelicans, with their bulky-gangly bodies, looked ridiculous perched in the trees lining the riverbank—holding

Whimbrel and Willet

on to branches with their dark gray webbed feet. And if I were to imagine what a pterodactyl looked like, awkwardly taking flight in the Cretaceous period, it would be very similar to what a brown pelican looks like taking flight today.

Shortly after returning to the gulf, we spotted a domed object—roughly the circumference of a trash can lid—on the surface of the water. At first, none of us could figure out what it was. Then, as our driver slowed the engine and moved us closer, Jose said hesitantly, "I think it's an olive ridley sea turtle. I've never seen one on the surface of the water like that. It might be sick or dead."

Through my telephoto lens, I could see the turtle's shell, but it appeared as if its head was either missing or pulled inside. An instant later, the shell began to sink and a large head popped out of the water. "It's alive!" I said.

As sea turtles go, olive ridleys are common. However, their numbers have dropped by 50 percent since the 1950s, largely due to egg gathering and getting caught in fishing nets. Most countries, including Costa Rica, protect the turtles. But even the protection is controversial, as the Costa Rican government allows 120 families from the coastal town of Ostional

Brown Pelicans

to engage in limited "sustainable" egg gathering. The government's rationalization is that by limiting egg gathering to the first thirty-six hours of a mass nesting period (called an *arribada*), the families are mostly taking eggs that later arriving turtles would have destroyed anyway, and those families will protect the remaining eggs to ensure profitable future harvests.

Olive Ridley Sea Turtle

How do I feel about Costa Rica's turtle egg exemption? The Costa Rican government puts forth a persuasive argument that the program is actually increasing the local turtle population. On the other hand, it is arguably enabling the overseas turtle egg black market (how do you prove where the eggs came from?), where unscrupulous profiteers sell the eggs as

aphrodisiacs to the same class of primitive idiots who ingest powdered rhino horn, expecting a variety of cures. So while I'd normally give an ecologically forward-thinking government like Costa Rica's a greater benefit of a doubt than I would give a drill-baby-drill government like Alaska's, I just can't go there with them on this one.

As for the olive ridley sea turtle in front of us: she held her head above water for a minute or so, while we inched closer and raved about our sighting. Then, in one smooth motion, she ducked her head below the surface and was gone.

Our motorboat driver accelerated the engine. Soon we were moving so fast that I figured he and Jose had communicated to each other that it was time to return to the lodge. In fact, this time we were much farther out in the gulf than before—away from where the previous dolphins were sighted; away from any shorebirds that could distract us. Suddenly our driver slowed the engine, stood up, and said something to Jose in Spanish. He cranked the throttle, and we were moving again. After a minute or two

passed, he slowed the engine once more and repeated the process.

"We think we see spotted dolphins feeding out there," said Jose, pointing toward the opposite shore.

I couldn't see anything but open water. Golfo Dulce is roughly twenty-five miles long and seven miles wide. Fortunately, we didn't have to cross as far as I expected. In a matter of minutes, the dolphins were in sight—even for my eyes.

"The water is just bubbling with them!" said Deb.

"I have never seen so many feeding like this," added Jose.

The next ten or so minutes were filled with rapid pointing and frequent cries of "There's another one!"

This was the dolphin experience I had been hoping for. I'm not sure how many dolphins were in the pod we were watching, but pods can be as large as one hundred or more individuals. We also got to see what they were eating, as thousands of little silver-and-blue fish would take to the air in front of them. So many little fish, in fact, that at times they formed a virtual wall extending several feet above the water's surface.

Dolphin Food

Spotted dolphins are the species of dolphin most affected by fishing, as they tend to hang out with yellowfin tuna. In the 1980s, U.S. tuna fishing operations killed about 130,000 spotted dolphins each year. Since then "dolphin-safe" fishing methods have dropped deaths to about 30,000 a year. But that's only what the U.S. fleet kills. Worldwide, countless thousands more die because of the human appetite for tuna.

At that moment, however, tuna fish sandwiches weren't on my mind.

Spotted Dolphin

Instead I was enjoying a day filled with amazing wildlife experiences. Also, the fact that the temperature here was in the eighties and back home it was in the twenties didn't hurt matters either. I do think that people who live in areas with frigid winters enjoy tropical getaways far more than those who already live in warm climates.

Eventually the spotted dolphins moved on, and so did we. Our driver turned the boat toward shore and headed for the lodge.

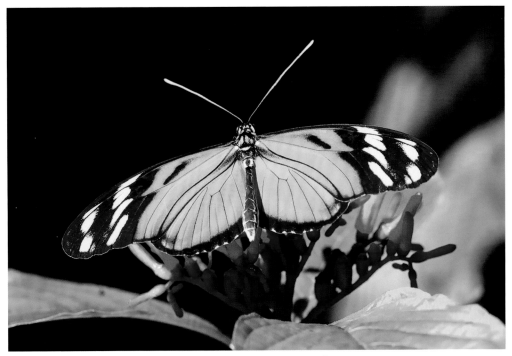

Hecale Longwing Butterfly

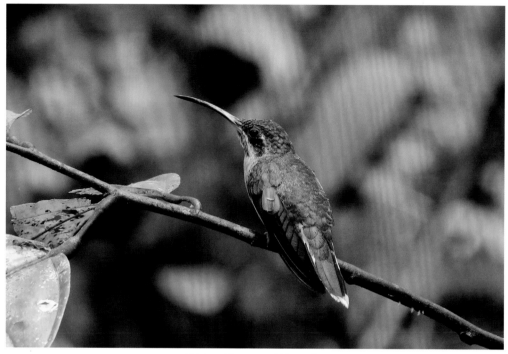

Stripe-Throated Hermit

For the rest of our day, we relaxed, went for a swim, and watched the National Geographic Channel at our cabin. Of course, we didn't actually have a TV in our cabin. Instead we said "hi" to Fred the eyelash viper next to our steps, enjoyed brief visits from a variety of birds and butterflies, and even watched a small troop of white-faced capuchin monkeys go by.

And if that weren't enough, we witnessed an epic battle between a four-lined ameiva lizard and a large katydid. One wouldn't expect the katydid to have a chance, but it was obviously releasing some sort of bad-tasting chemical. Each time we thought the lizard would swallow the katydid, he would spit it out and try again. After a bit, we left the two alone. When we checked back later, the katydid was gone, so we assumed the lizard won.

Four-Lined Ameiva Lizard

As mentioned earlier, Deb and I had signed up for the Frogs, Bats, and Snakes package. So far we had seen a fair number of frogs and snakes, but the only bats we had seen were those that whizzed by our cabin when we were on our porch and our heads when we were hiking at night. Although I never learned how the lodge incorporated bats into the guided portion of our package, the two of us figured out how to find them ourselves.

Costa Rica supports roughly 110 bat species. That's 10 percent of the world's bats and twice the combined species total found in Canada and the United States. Our plan for the day was to hike out to an abandoned farmhouse that humans last used when the property was a cocoa plantation. Apparently the bats had converted the farmhouse into a bat house.

Logically, one might expect such a house to be near the gulf. Instead, it was actually a mile or so inland. In other locations, such a short hike wouldn't take long, but here—at least for us—we needed to triple our expected hiking time to accommodate anticipated wildlife encounters. We packed plenty of water and snacks and hit the trail right after breakfast.

Twice we had seen white-faced capuchin monkeys pass by our cabin. Both times, however, the monkeys were high in the trees and moving fast. One-half hour into our hike, we finally had the opportunity to see the monkeys a bit closer and for a little more time. You may not recognize the

White-Faced Capuchin Monkey

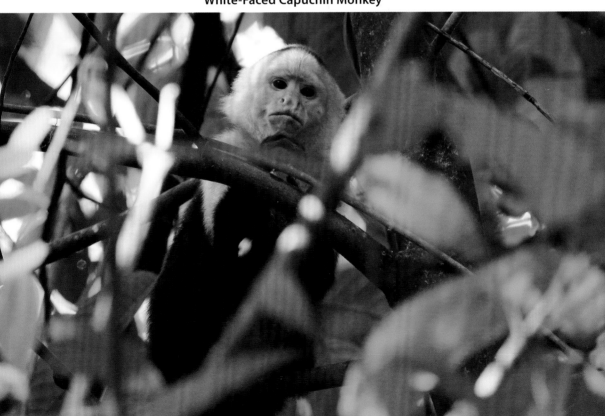

name white-faced capuchin monkey, but I bet you've seen one in an old photo. These are the traditional organ grinder monkeys that were part of novelty street performances, from the nineteenth century into the early twentieth century.

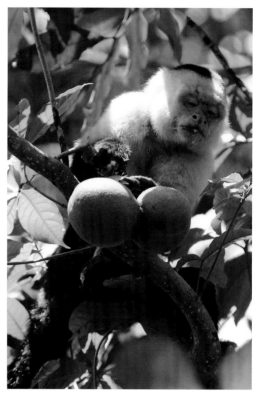

The monkeys were perhaps forty feet up in the trees, and we learned quickly that it was dangerous standing directly beneath them. They were eating hard softball-sized fruits that the locals call *donkey balls*. Apparently the fruits weren't quite ripe, as the monkeys would take a quick taste, and then nonchalantly drop them. At first glance, the monkeys seemed wasteful, but those fruits weren't going into some landfill. They were landing on the ground where they would become food for other animals, who in turn would continue the cycle by dispersing the seeds.

When we planned our hike to the farmhouse, I immediately thought of the two-story farmhouse my grandparents had owned in northern Minnesota. I knew the Costa Rica house wouldn't be as big, but I hadn't imagined it being the size of a three-room shed either. As we approached, I could see that the front door of the unpainted, wood plank building was missing, and bats were flying in and out. Although the traffic was infrequent, that any bats were flying on a sunny day surprised me.

I stepped inside to the rapid *ta-ta-ta-to* of panicked wings. Like a horror movie, when you expect the villain to reach in from the dark and grab the girl's leg—and still jump when it happens—I had expected the thunder of flutter and still jerked back my head.

Soon the bats calmed down, allowing me to scan the walls of the small front room. Only a few bats lingered here, as light filtered in through the door and a partially open window shutter. I could hear many more bats in the two dark rooms. The bats in the front room were greater white-lined bats. Two wavy white lines running down their backs made them easily

Greater White-Lined Bat

distinguishable from other species. Another fitting name for them would have been *Velcro-ball bats*. They'd cling to the rough plywood walls, and if frightened, they'd fly out a few feet and back—sticking instantly to the wall, as if they were Velcro balls hitting self-stick mitts.

Entering the large, dark back room was intense. When I shined my flashlight on the rough sawn support beam, three rows of shoulder-to-shoulder bats glared back at me. Several bared their fangs and some took flight. I could feel the wind from their wings! The only time I had experienced bats like this was at Culebrones Cave in Puerto Rico, but here they had less flying room. Even though catching rabies from bats in Costa Rica is extremely rare, the disease is usually fatal for humans. Should a bat miscalculate its flight and end up scratching or biting me in a panic, rabies shots would be necessary.

On the other hand, this was a great opportunity to get some spectacular photos. Aside from having to steel my nerves, the lack of light created focusing problems for my camera. When I stepped outside to check the first series of photos on my digital SLR's screen, they all looked blurry. Shining a

Seba's Short-Tailed Bats

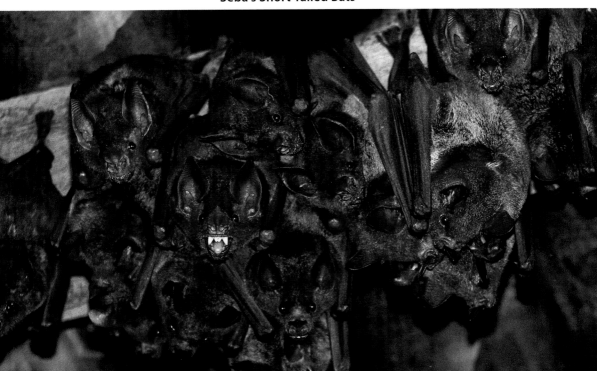

flashlight directly on the bats didn't work much better, as the light combined with the camera flash to wash out part of each photo. The key was to light the bats, focus, turn off the flashlight, and shoot using only the camera's flash for illumination. I shot a series of photos doing everything myself but felt I could get crisper shots if—"Deb, I need you!"

"You're going to make me go inside and help you. Aren't you?"

"It would really help."

"*Ooo . . . kay.* But you owe me!"

My wife is a brave woman.

By looking at my photos afterward, I could tell that three species of bat occupied the farmhouse: greater white-lined bats, Seba's short-tailed bats, and another species I couldn't positively identify.

We also had a farmhouse bonus find—a Central American smooth gecko (sometimes called a *turnip-tailed gecko*). These large geckos reach eight inches in length and are capable of changing colors to blend in with their surroundings. The one we found matched the interior wall of the farmhouse so well that her feet appeared fused to the wood.

The rest of our day was somewhat uneventful— for Costa Rica anyway. After returning to the lodge, we still had a few hours before the afternoon rainstorm. Deb took a book and retired to the hammock near the beach, while I backed up my photos and spent some time photographing birds and butterflies.

Central American Smooth Gecko

My running joke with Deb was that since I always seemed to have the wrong lens on my camera, I needed a caddy, like golfers have. I'd do my best whispering golf announcer impression:

"Marty is approaching the scarlet macaw. . . . It's a tough shot from where he's standing. The bird is up high, in the rough, with heavy foliage on each side. He won't be able to reach it with a wide-angle. He'll need at least a 300-millimeter telephoto, and he's going to have to be precise. He holds out his hand and his caddy hands him a . . . What's that? It's a 55-to-250 millimeter zoom! Oh! No! That's the wrong lens for the job, Bob. He'll never make that shot from there."

"You're absolutely right, Joe. And you can see the anguish on Marty's face, as he glares at his caddy."

"Finally, his caddy hands him a 300. Marty can switch lenses faster than anyone on the tour, but I'm afraid even he won't be quick enough this time."

"Marty is back into position. Finger poised over the shutter button. He takes a deep breath, and—there goes the macaw!"

"Marty is absolutely livid, Bob! He's been trying to get the scarlet macaw all week, and now he loses it due to a caddy error. What a crushing moment to get so close and lose that way. . . ."

At that moment, I wasn't thinking about a lens caddy. The sun was low in the sky, and since I wouldn't be going far, I left my smaller lenses in my backpack at the cabin. With just my digital SLR and 300mm telephoto lens, I leisurely walked toward the beach to meet up with Deb.

Along the way, I spotted a white-nosed coati, which was a fun find but a difficult shot in the fading light. By the time I reached Deb, she was just getting up to witness the birth of a sunset.

All of the previous sunsets we'd seen in Costa Rica had been beautiful. This one was going to be especially stunning. I lifted my camera. *Damn!* My 300mm telephoto was a fixed distance lens for faraway objects; not a zoom lens you could pull back for a wide shot. I contemplated running back to the cabin for a smaller lens, but there was no way I'd make it back before the sun disappeared.

Even though I'm a self-taught photographer, I know a common lesson in photography classes is to send students out with the wrong lens for the job. With that in mind, I did my best with what I had. I needed to focus and reframe multiple times to capture just the elements of the sunset that were important. Now, in retrospect, I'm pleased that my only choice was the wrong lens. But that doesn't mean I still don't want a lens caddy.

By the time our last night at the lodge arrived, the guest list had completely changed. Yvonne and Paul had departed, and a large number of people had arrived to be there over the upcoming Christmas holiday. Now instead of just four people sitting at the long dinner table for each meal, we had about twenty. Although I enjoyed meeting the new people, I missed the private feel the lodge had earlier.

Deb and I had worn T-shirts and shorts throughout our stay. In case we wanted to dress-up a bit, she had packed a casual dress, and I had packed a polo shirt. Being that this was our last opportunity to do so, Deb put on her dress, and I put

Rainforest Chic

on my shirt. An on-going battle everyone experiences in the rainforest is keeping one's clothes dry. My polo shirt felt as if it had sucked up enough humidity to support a new and exotic fungal colony. I promptly peeled it off and put on a fresh T-shirt. We walked to dinner, with her dressed significantly better than me.

The main lodge has two floors. Steps lead up the middle of the building, with the open-air bar on the left and the open-air dining room on the right. Our typical routine was to go left and have a drink until Andrés, the lodge manager, called us to the dining room for dinner.

On this night, when the call came, we stood up with everyone else to walk across for dinner. Andrés stopped us. "Deb, Marty, come with me. We have a special meal set up for you downstairs."

He led us down the stairs to the patio, where the staff had set up a

private dinner on a candlelit, flower-covered table. "Happy Anniversary!" he said.

"Oh my God. This is beautiful!" said Deb.

"What a nice surprise. Thank you Andrés!" I said.

Deb patted her heart. "I'm getting all choked up."

The two of us sat, toasted the occasion, and enjoyed our private meal.

"Look behind you," whispered Deb.

Well, almost private. A hungry raccoon stood behind my chair, sniffing the air, eager for a handout. Deb shooed him away.

At first, I was disappointed about the raccoon's forced early exit, but my wife was right. Handfed wild animals soon become dead wild animals, and we didn't want to encourage bad behavior—even if it was cute. The raccoon visited us several more times during the evening, albeit a little more shyly each time.

Ringed Kingfisher

I woke up early the next morning. Our flight back to San José wouldn't depart until after lunch, and I wanted to use the last few hours to see if I could photograph some animals that had eluded me.

The length of our stay had been almost perfect. Although every day had been good for finding and photographing wildlife, our animal sightings were starting to get repetitive. I don't mind watching an exotic species of bird, snake, or frog more than once, yet the first time is always special, because it's a challenge successfully met. I've traveled all seven continents, and one thing all those travels had in common was a moderate portion of my hope-to-see list left unfulfilled.

On this trip, my hope-to-see list was down to three animals: a

bushmaster, a sloth, and a scarlet macaw. Jose had warned us that sloth and bushmaster sightings were highly unlikely. As for scarlet macaws, technically I had seen them, but each sighting was either far in the distance or a quick glimpse of a tail disappearing into the foliage.

With scarlet macaws in mind, I headed for the beach. A few days earlier, Manfred, another lodge guide, had suggested that the almond trees along the waterfront were a favorite macaw hangout.

I hiked north first. Twenty minutes of searching didn't produce any macaws, though I did photograph a nice ringed kingfisher as a consolation prize.

I turned and hiked south. After thirty minutes, I was almost ready to return to the cabin to see if Deb was awake. I had been strolling along the freshwater stream that parallels the beach. I stopped when I reached a raised wooden boardwalk, which crossed the stream and continued into a swampy section of rainforest. The boardwalk was rotten and obviously no longer in use. That was something I nearly found out the hard way earlier in the week. I had been inching along it, when a board broke and almost spilled me—and my camera gear—into the water.

Now my goal was to photograph the boardwalk, not walk on it. While a sturdy structure is best for walking, a rotten structure is best for photographing. I was just setting up the shot when I heard the unmistakable sound of scarlet macaws squawking in the distance. They were flying my way.

"Damn! Wrong lens."

I dug into my backpack and quickly grabbed my trusty 300mm lens. I should have also grabbed my 1.4x lens extender, but even my ability to "switch lenses faster than anyone on the tour" has its limits. Soon two macaws were in sight, flying directly parallel to my position. I aimed and shot—*click, click, click, click, click*—following them across the sky.

"Yes!" I had my scarlet macaw shots.

Scarlet Macaws

I returned to the cabin to tell Deb the news. Although my wife did a good job of being excited for me, she was obviously a little disappointed about not seeing the elusive parrots herself. Fortunately, she wouldn't be disappointed for long.

After breakfast, we squeezed in one last short hike. Starting near Deb's favorite hammock, we walked south to the rotten boardwalk. There we stopped for some frog spotting and both found smoky jungle frogs. We continued on and hadn't traveled fifty feet before two macaws started squawking. They were in a tree right above us!

As we maneuvered into viewing position, one flew off. The other stayed in the tree, giving Deb a nice look and me the opportunity to photograph a stationary macaw. With red, blue, and yellow on their wings, and a deep-red body, scarlet macaws are a striking sight. Although not quite an endangered species, both the illegal pet trade and habitat fragmentation have reduced their numbers. Luckily for the parrots, they are a charismatic species, and the same appeal that spurs illegal pet trade demand also spurs counteraction with conservation and captive breeding-and-release programs. That may not be ideal for intelligent, long-lived birds like macaws, but it sure beats extinction.

What a great way to end our Costa Rican adventure! We had seen almost every animal we had hoped to see, from scarlet macaws to eyelash vipers to howler monkeys. As a bonus, we also saw animals such as Jesus Christ lizards, Central American agoutis, and spotted dolphins that weren't on our hope-to-see list but were memorable finds nonetheless.

We finished our short hike, said good-bye to Fred (who was now one leaf over from where he was on the night we found him) and the lodge staff, and headed for home. Costa Rica is truly an Eden for animal lovers. And it's not a bad place for a thirtieth anniversary either.

—————— **Epilogue** ——————

One thing I wrestle with, as an author, is recommending places that have become favorites of mine. Why contribute to an influx of tourists who might eventually ruin what made that place so special to begin with?

I advocate Costa Rica without hesitation because it's a country that seems to have its values in the proper order. Rather than engaging in conflict with other countries, Costa Rica abolished its military in 1948 and invested much of the money saved into education and culture. In addition, Costa Rica has recognized wildlife and natural habitats as national treasures to be protected. Not only has the country banned recreational (non-subsistence) hunting, but it has also set aside roughly 25 percent of its land for conservation. Various studies consistently rate Costa Rica among the greenest countries in the world. In fact, the 2014 World Energy Council rankings put Costa Rica as the second best country in the world for "environmental sustainability" (the United States is eighty-third on that list).

With all that peacefulness and greenness going on, someone subscribing to a Fox News point of view might think that Costa Rica is a poor, uneducated country, in constant danger of terrorist attacks. Various quality of life indicators say otherwise.

The average life expectancy in Costa Rica is 79.8 years (the same as the U.S.); the literacy rate is 96.3 percent (in the U.S. it is 99 percent); the percentage of GDP spent on education is 6.3 percent (in the U.S. it is 5.4 percent); the obesity rate is 23.7 percent (in the U.S. it is 33 percent); and the 2014 Gallup-Healthways Global Well-Being Index lists Costa Rica second among all countries, with 44 percent of its residents thriving in at least three well-being categories (the U.S. is fourteenth, with 33 percent of its residents thriving).

The above statistics do not say that Costa Rica is a better country than the United States or that Costa Rica is a country without problems. What they do say is that Costa Rica has proven that military might and environmental plunder are not necessary for a country and its people to be successful, healthy, and happy. And as more and more tourist dollars help Costa Rica "cash in" on being peaceful and green, other countries will follow their example. That can only be good for our planet as a whole. So do your part to save the world—visit Costa Rica!

About the Author

Marty Essen lives in Montana with his wife, Deb, two dogs, and three rainbow boas. When not traveling or writing, he speaks at colleges from coast to coast. His humorous, high-energy show, *Around the World in 90 Minutes*, is one of the most popular slide shows of all-time.

Be sure to read Marty's six-time award-winning first book, *Cool Creatures, Hot Planet: Exploring the Seven Continents.*

Readers wishing to contact Marty may do so via e-mail, Marty@EncantePress.com, or Facebook, www.facebook.com/marty.essen.

Please visit www.MartyEssen.com for information on Marty's speaking engagements, signed copies of his books, and signed photos from this book.

And finally . . . if you enjoyed *Endangered Edens*, please post a review on both Goodreads and your favorite bookstore's website.

Six-time award winning book!
Cool Creatures, Hot Planet
Exploring the Seven Continents
Marty Essen